MW00851962

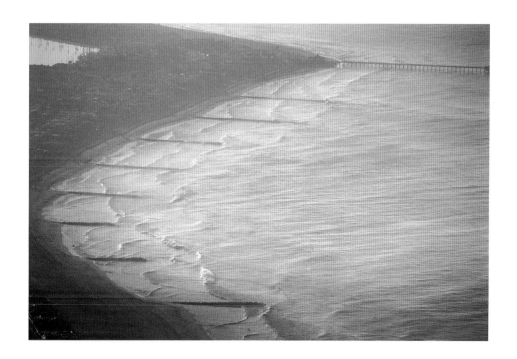

Newport Beach from above. The two jetties at the bottom, 52nd and 56th Streets, frame the 100-yard stretch that is Echo Beach.

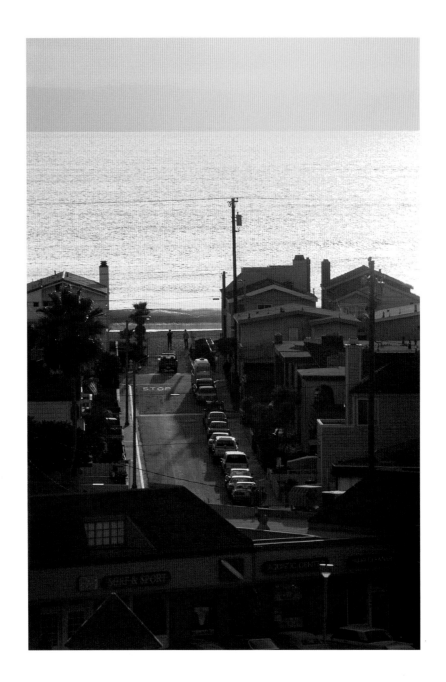

The view from Superior Avenue hill.

THE EIGHTIES
AT
ECHO BEACH

PHOTOGRAPHS
MIKE MOIR
(UNLESS OTHERWISE NOTED)

INTRODUCTION
JAMIE BRISICK

FOREWORD
JOEL PATTERSON

CHRONICLE BOOKS
SAN FRANCISCO

THE HOTTEST HUNDRED YARDS

Though it's a seven-digit-plus real estate market, locals call the densely packed community that surrounds 54th Street in Newport Beach the "surf ghetto."

Under a net of crisscrossing phone lines that make the perpetually washed-out blue sky look like a heavenly Sudoku puzzle, square footage is at a premium. Owners build to the edges of property lines, creating massive, boxy eight-bedroom duplexes that stand so close to one another that from certain angles they seem connected. And they might as well be. Few structures in the ghetto have ever been owner occupied, but instead contain an army of well-tanned surfers living hand-to-mouth and renting month-to-month. They share the peaky beach breaks by day and 12-packs of Bud by night, when parties spill from house to house and Newport's finest cruise slowly through the narrow streets.

The neighborhood was nearly identical in the early 1980s, when a group of ghetto dwellers under the influence of the Talking Heads, and twin-fins so brightly airbrushed you could see them from space, forced Upper West Newport into the consciousness of surfing forever. This book is a celebration of them—the first generation of photo pros. But before we relive the birth of Echo Beach, as they named it, it behooves us to acknowledge those who recorded this monumental, if brief, era.

Without photographers, there are no photo pros. Without Mike Moir's innovative angles and approach—which shifted the focus from surf photography's traditional goal of making the wave the star to putting the subject's personality as well as the surf action in the spotlight—the Echo

Beach phenomenon likely wouldn't have had the resonance it did. Moir shot from ladders, jetties, the water, and the beach, because, just like the surfers he was documenting, he thrived on the good-natured competitiveness that went into everything from riding a wave to dressing for a big night out to snapping the shutter. Moir didn't just shoot the scene; instead, his imagery became a key player in the movement that would open an entire new path for surfers to earn a living doing what they loved.

Writer Jamie Brisick wasn't a full-time member of the Echo Beach crew, but you wouldn't have known that from his wardrobe. A product of the equally eccentric scene at Malibu, an hour north up the 405 freeway, Jamie joined the McCoy Surfboards team in 1980 and got sponsored by Quiksilver, the company at the vortex of the movement, a year later. For Brisick, the Echo Beach scene felt natural, and he was in lockstep with the local ethos that being a pro surfer wasn't just about making magic in the water, but it also included your clothes, hairstyle, and duffle bag. Echo Beach wasn't just a time and place, it was an attitude, and Jamie was a believer.

Throughout the decades, as the neighborhoods in the surrounding higher ground have gentrified, replacing the beater Volvo station wagons of middle-class families with the Bentleys of the well-healed, the ghetto has resisted. At night, beer bottles clink, cops cruise, and occasionally one of the renters will howl like a coyote. Along with images and legends, signs that Echo Beach is still alive and well.

Joel Patterson

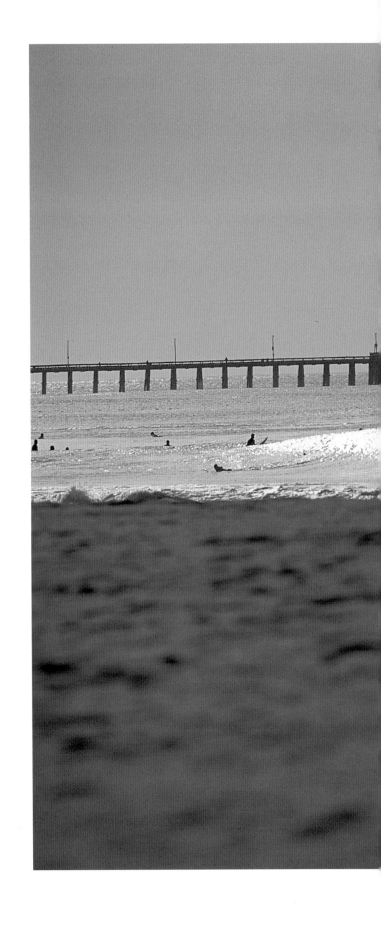

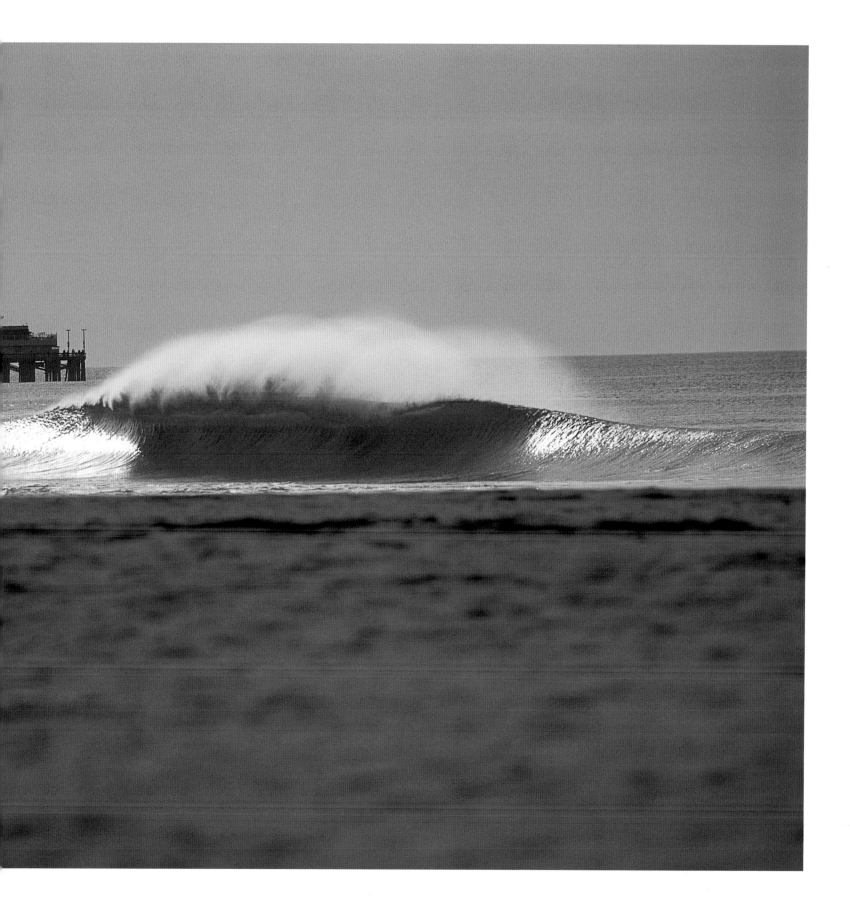

"We felt like rats in a cage," remembers Danny Kwock. "The ocean was our salvation."

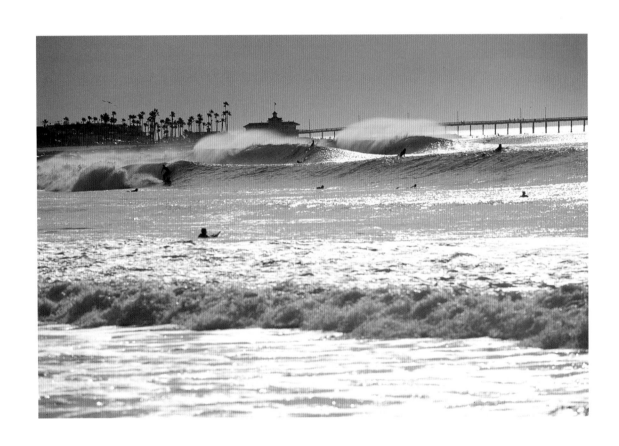

"When they put in the 56th and 52nd Street jetties, it contained all that sand right there," remembers Greg Pautsch.
"And that was always where the biggest waves broke."

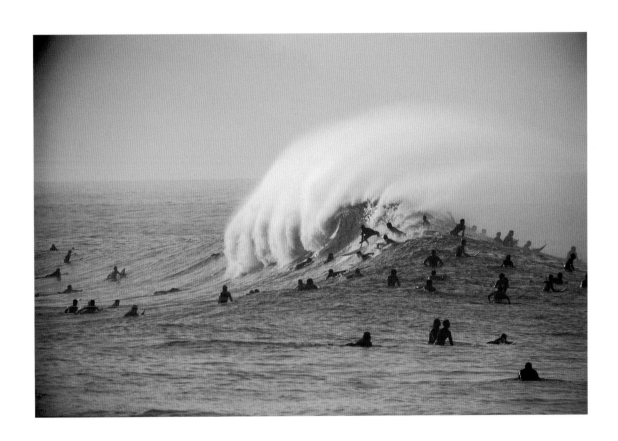

Newport broke year-round, but south and southwest swells transformed it into a veritable skate park.

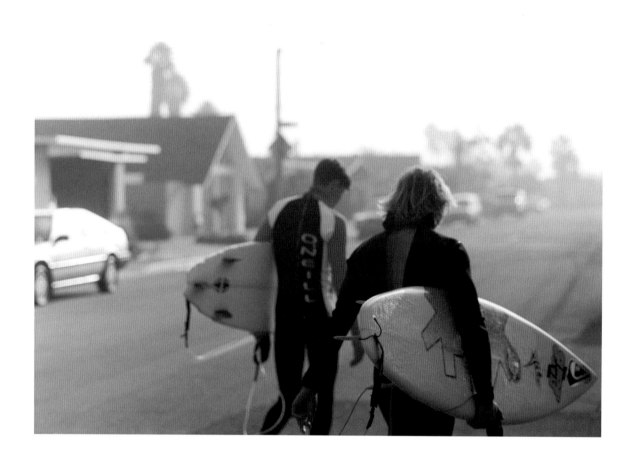

The "surf ghetto," awash in peroxide blondes on beach cruisers and Day-Glo-clad dawn patrollers.

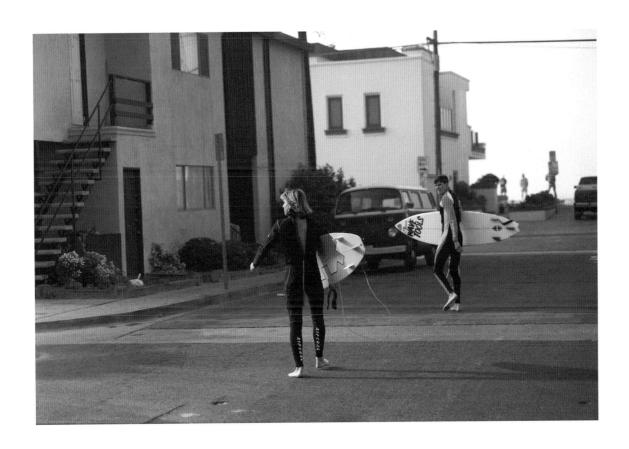

Fifty-Fourth Street led straight to the sand, creating a kind of pearly gates entrance to Echo Beach. (L to R) Robbie Todd and Mike Estrada.

YOUNG, LOUD, AND SHAMELESS

On a bright summer morning at Echo Beach, a pack of surfers straddle their boards, eyes fixed seaward. They look nothing like the surfers you'd find at neighboring beaches. Instead of black wet suits and clear boards, these guys resemble a troop of circus clowns.

Danny Kwock wears a pink, white, and turquoise full suit, his 5'6" twin fin bedecked with polka dots. Preston Murray sports a Ronald McDonald-like red and yellow wet suit and matching board. Jeff Parker glows in canary yellow and candy stripes.

Louder than their colors, however, is the constellation of stickers that cover their boards: Quiksilver, Wave Tools, Gotcha, Stussy, McCoy, Rip Curl, Newport Surf and Sport, Schroff, O'Neill. Each logo represents a photo incentive contract. Cover shots will fetch them roughly $500. Postage stamp–size images $10.

This explains the photographers. On the 52nd Street jetty, Dave Epperson, Chuck Schmid, and John Ker clutch Nikons and Canons. At the shoreline, Steve Sakamoto and Peter Brouillet stand behind tripods. In the water, Mike Moir bobs in the impact zone with his trusty fisheye. When a set of sapphire blue A-frames march shoreward, the photographers on the jetty whistle and point. Their elevated perch allows them to see what the surfers can't.

"Out the back!" shouts Epperson. "Third one's the gem!" adds Schmid.

As the peaks stand up, the surfers jockey for position. Parker takes off on a double overhead right and blasts into a dramatic frontside slash, his fins flying over the back of the lip. Kwock angles down the face of a heaving bowl, stalls, and manages a stylish lay back in an almond-shaped tube. The motordrives sound like rattlesnakes.

The third wave is the biggest, but a dumping closeout. Murray paddles frantically to meet its apex. He strokes once, pops to his feet, and tucks straight into the barrel. Moir is in perfect position. As the frothy lip curls

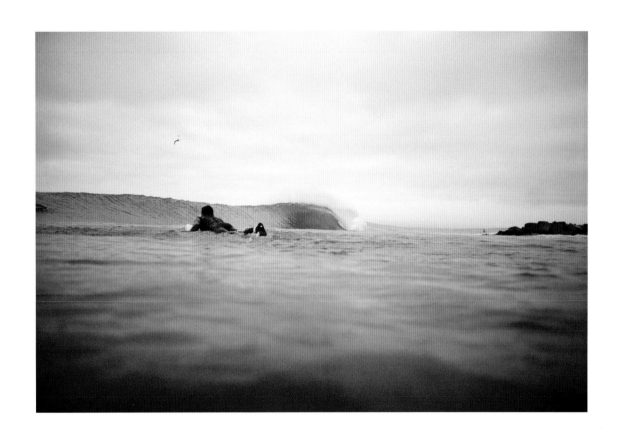

"There was this great pattern of weather," remembers Preston Murray. "For a couple summers, it was overhead and barreling every day."

over his head, he aims then squeezes the trigger of his Plexiglass water housing. For a fleeting second, he and Murray are encased in a spidery glass cocoon. The wave explodes. When they emerge from the spin cycle, Moir whoops and flashes a thumbs up.

As the morning progresses, the crowd thickens. John Gothard, Smerk Mangan, Peter Schroff, Craig Brazda, Steve Richardson, Hugh Johnson, and twelve-year-old Richie Collins are all brightly outfitted and bantering. The session heats up. Lips are stabbed, and spray is hurled. They forgo beautiful lefts because lefts are unfavorably backlit. They waste long sections for that one giant kill maneuver. They are less surfing than modeling. On a recent blown-out afternoon, Murray confessed to Parker, "I don't even like surfing unless the cameras are out."

Between Newport's 52nd and 56th Street jetties, recently dubbed Echo Beach, these photo sessions have become a morning ritual. It helps that the players all live within walking distance. Parker rents couch space in a house across Pacific Coast Highway. A star football player in high school, he gave up scholarship offers to pursue his pro surfing dreams. His blond hair is gelled into a great bird's nest of a pompadour. His favorite band is the Stray Cats.

Kwock and Preston share a small apartment on 48th Street. So frequent are their Friday night parties that the local cops know their address by heart. Kwock is elfin,

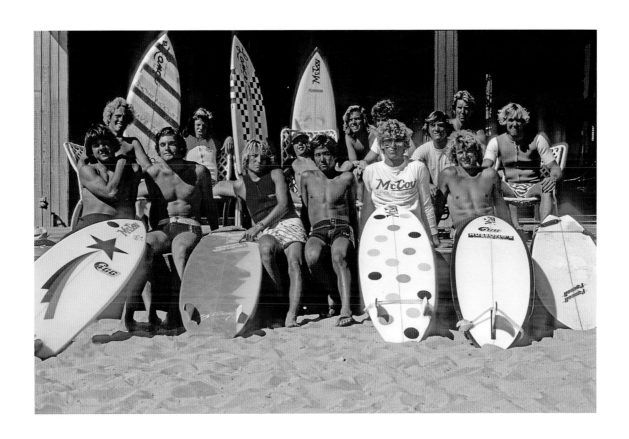

(L to R, top row) Rod Bell, Jeff Parker, Preston Murray, Greg Hill, Andrew Coutts, Dorian Ronai, Nigel Kent, John Gothard;
(L to R, bottom row) Ross Morgan, Dave Noel, Alan Lopez, Danny Kwock, Craig Brazda, Geoff Madsen. (Photo: Chuck Schmid)

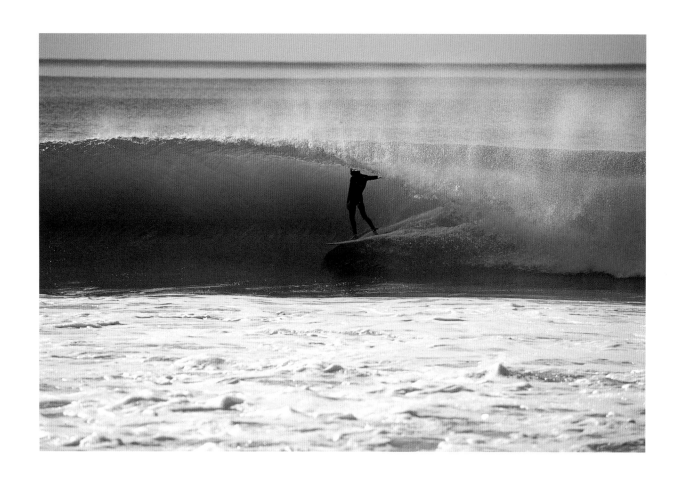

The jetties gave swells a point of focus, a finger of rocks to ricochet off. Fifty-Sixth Street delivered rights; 52nd Street lefts. (L) Kirk Blackman and (R) John Hume.

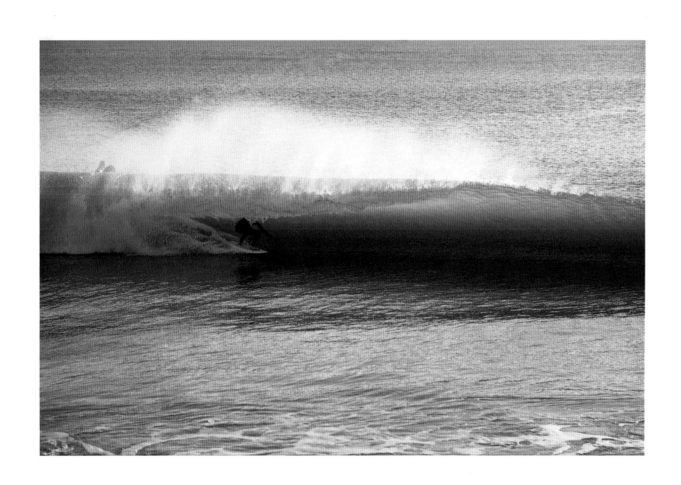

Chinese-Hawaiian, gregarious. He made his reputation pulling into homicidal closeouts at The Wedge; an evil shore pound notorious for breaking necks. Murray is slender, handsome, laid back. He recently quit his job stringing tennis rackets so that he can surf full time.

Between sessions they "cruise chicks." In summer, Echo Beach swarms with jaw-droppingly gorgeous girls. In the evenings, they gather at the local Winchell's, where a surfer buddy hooks them up with free donuts. Over apple fritters and chocolate French crullers, they replay their finest rides with matador-like body language. Weekend nights are spent at Déjà vu. In this smoky club, they dance under strobe lights to Devo, B-52s, Suburban Lawns.

But sunshine and south swell is their alarm clock. The curtain rises at roughly 8:00 A.M. And every shimmering blue wall is a potential cover shot.

* * *

Like most countercultures, Echo Beach was ignited not by one thing but several, an aligning of stars. In the early eighties and then again later in that decade, a 100-yard stretch in Newport Beach became a launch pad for breakaway trends and movements in the surf world. Fronted by Danny Kwock, Preston Murray, and Jeff Parker, it would influence everything from fashion to board design to the way we think about pro surfing.

The roots of the beach trace back to the twenties and thirties, when a thriving surf scene emerged out of Corona del Mar, a Waikiki-like break on the southern end of Newport Beach. Pioneering wave riders like Duke Kahanamoku and Tom Blake "walked on water," much to the astonishment of summer beachgoers. The Corona del Mar Surfboard Club, founded in the late twenties, was the mainland's first surf organization. But a jetty extension in 1938 essentially

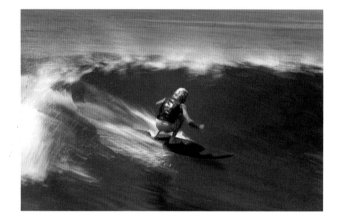

John Van Ornum, speeding through the seventies.

killed the break, pushing surfers a couples miles north to The Point and Blackies, both faster, hollower waves.

Throughout the fifties and sixties, these spots, along with Santa Ana River Jetties a few miles north, were Newport's premier surf hubs, abuzz with stoked kids shooting curls, walking noses, and hanging ten.

In 1966, *Surfer* magazine ran an article titled "Pipeline Comes to Newport Beach." Chockablock with black-and-white photos of North Shore–style tubes, it attracted surfers in droves. But as the lineup swelled, so did the city's efforts to regulate it. For a surreal couple of years, surfing was unlawful without a "surfboard permit." At a cost of $3, you were issued a mylar sticker that was to be affixed to the bottom of your board. The lifeguards drove up and down the beach, shouting through loudspeakers for surfers to show their permits. But of course this didn't last long. So copious were the forgeries that the city eventually conceded defeat.

Surfing was forever changed when Australian Nat Young won the 1966 World Surfing Championships in San Diego on "Magic Sam," a 9'4" squaretail that was shorter than the standard boards of the day. While his competitors drew straight lines, Nat careened up and down, ushering in the Shortboard Revolution. By the early seventies, boards had shifted from 10-foot "tankers" to zappy, 7-foot "pocket rockets."

This coincided perfectly with what was happening in Newport Beach. In 1968, the Army Corps of Engineers began construction on a series of eight rock jetties along the mile stretch between 36th and 56th Streets. Their intention was to curtail sand erosion and thus protect the million dollar beachfront homes, but in fact they were creating surf spots. The jetty at 56th Street produced a

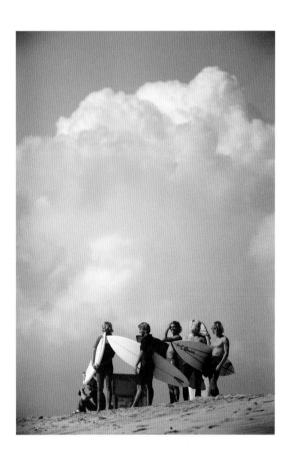

Single-finned surfers gather at 54th Street in 1978.

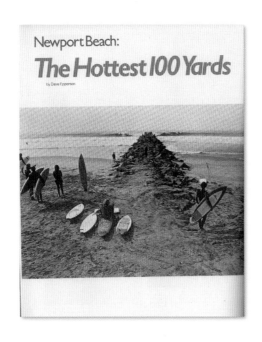

Newport Beach:
The Hottest 100 Yards
by Dave Epperson

SURFER

OCTOBER
VOL. 22 NO. 10
$2.50
14246

THE SURFBOARD: Variations and innovations
SURF MUSIC '81
TOM CARROLL EXPLODES
RHODE ISLAND'S BEST

SURFER

MARCH 1980
VOL. 21, No. 3
$2.00
CDC00568

Hawaii; North Shore Action
New England's Quality Waves Revealed
A Day to Remember; Lopez, McCabe Rip Padang
California Portfolio by Mike Moir

SURFING

FEBRUARY $2.95

BEYOND SOUTHERN CALIFORNIA
Up North & Mexico Explored

TOM CURREN
POSTER INSIDE

A Tribute to the Power & Passion

Overnight sensations: (clockwise) 56th Street jetty; Jeff Parker; John Gothard; Danny Kwock.

shallow, perfectly shaped sandbar. On sleek pintails, local rippers like Lenny Foster, John Van Ornum, and Ed Farwell spent unforgettable seconds in the illustrious "green room." In summer, on big south swells, it looked like Uluwatu.

In 1976, the International Professional Surfers (IPS) was formed, creating a world tour and an integrated yearly ratings system. On the North Shore, a band of cracker-jacks from Hawaii, Australia, South Africa, and the mainland United States pushed the boundaries of big wave riding. World-class breaks were discovered in Africa, Europe, Indonesia, and South America. A model was formed: to be a pro surfer you had to deliver big results on the IPS tour, charge monster surf in Hawaii, or travel to far-flung places. Ideally, you did all three.

Concurrently, a kind of anti-pro ethos took root in California. Black wet suits and clear boards were ridden in protest of the flourishing surf industry. Contests were deemed uncool. Surf mags were condemned for exposing sacred waves. In Oxnard, Palos Verdes, and San Diego, embittered locals protected their breaks from outsiders by smashing windows, popping tires.

But at Echo Beach, an entirely different scene was surfacing. A few years after 56th Street was complete, a twin jetty was built 100 yards south at 52nd. The two rock fingers held the sand in place, creating short, bowly peaks conducive to big, radical maneuvers. The waves were consistent and broke close to shore—a mere three or four strokes and you were in position. The jetties offered an excellent angle for photographers. It was the perfect stage. All it needed were actors.

Enter Kwock, Preston, Parker, and crew. They were young, loud, and hungry to prolong their Endless Summers.

"We wanted to be pro surfers," remembers Kwock. "But we weren't really into contests. I thought, 'How can I make this work? How can I keep my sponsors going so that I can keep surfing?'"

Kwock ordered what at the time might have been the loudest board in history: a polka-dot McCoy twin fin. On a bright summer morning, during a clean south swell, he slipped into a pair of blue-striped Dolfin shorts, paddled out at 54th Street, and banged the lip in front of the cameras. The resulting photo, vibrant compared to its muted late-seventies counterparts, embodied the giddy optimism of summer. It ran as a double-page spread in *Surfing*, with "California" inscribed beneath.

It snowballed from there. Much like London's Kings Road at the height of the punk era, Echo Beach became a kind of catwalk for outrageous getups. There were no rules, only that you express yourself boldly—in the water and out. Preston was given to terry cloth bathrobes on the sand. Parker sported Lucky Charms–bedecked twin fins and yellow wet suits with bright red crotches. Kwock was Mr. Polka Dots.

The photographers loved them. Their vibrant plumage turned even the "June gloom" days sunny. They understood light and composition; that you didn't have to make the maneuver, you just had to put yourself in that critical position for 1/500th of a second. They even bought the photographers' "B-shots," which they'd use to hustle new sponsors, who would in turn purchase ad shots from said photographers.

In 1980, *Surfer* featured an article titled "Newport Beach: The Hottest 100 Yards." Splashed with in-your-face shots of Echo Beach's rising stars, it validated what at the time was an entirely new phenomenon: the "photo surfer."

"These young kids are hungry," wrote Dave Epperson. "They want it and are willing to pay the price . . . They are only recently getting the attention they deserve, and it's only a matter of time before they bust down the door."

Mike Moir and his trusty Nikonos. (Photo: ©Dave Epperson)

He went on to point out the gold-rush mentality. "The word is out that the cameras are focused on 56th, so emerging surfers hoping to gain recognition use the spot as a springboard . . . For some of these guys, the cameras have the same effect as the bugler sending the troops off to war. They charge into the water with the spirit of a militant conqueror, only one goal in mind, to do battle with their fellow surfers and capture a spot in the magazines. They get wrapped so tight they are actually yelling down the line, 'Hey, don't take off; they're photographing me!'"

For the next two years, Echo Beach would become the most heavily publicized surf spot in California. It was a boon for the magazines. Located just down the road in Dana Point and Capistrano Beach, they realized that they no longer had to send their photographers halfway around the world to get the goods. And likewise the companies. Until then, a sponsored surfer's value was determined according to a jumble of intangibles (contest results, media coverage, popularity). The Echo kids looked good on spreadsheets: they were paid strictly by photo incentives. "Our mentality was: get as many stickers on the nose of your board as you can," remembers Jeff Parker. "That way you'd get paid as many times as possible."

What's more, the companies would soon discover that the photo is mightier than the contest. Kwock, Preston, and Parker became more famous than many of the Top 16-ranked surfers.

But it was more than just a photo thing.

Newport Beach's surf shop scene goes back to the fifties, when Joe Quigg and Pat Curren sold their handcrafted boards from garage-like stores near 30th Street.

In the glory days of the Shortboard Revolution, backyard shaper Russell's Balboa peninsula shop served as a kind of speakeasy for design-obsessed wave riders. In 1976, Paul Heussenstamm, a longtime employee of Russell, opened Newport Surf and Sport, a one-stop emporium.

That same year, USC grad Bob McKnight and pro surfer Jeff Hakman

Jetty construction, aka "Operation Sand Haul."

brought Quiksilver to the United States, infusing New-port Beach with a distinctly Aussie flavor. Midnight Oil blared from VW busses. Cheyne Horan and Rabbit Bartholomew stayed near 56th Street whenever the tour rolled through town.

Echo Beach was originally the name of a clothing range. Inspired by the uniforms worn by jockeys, Quiksilver founder Alan Green, along with artist Simon Buttonshaw, designed a series of boardshorts, pants, and jackets spangled in stars, checks, harlequins, and polka dots. In celebration Quiksilver put out an unforgettable ad: Australian surfers Kong, Bruce Raymond, and Chappy Jennings stand around (and on the hood of) an old sedan, clutching beers: "If You Can't Rock 'n' Roll," goes the text, "Don't Fucken Come!"

When Kwock and crew first saw the Echo Beach gear, they were ecstatic. Though conceived in rural Torquay, Australia, it perfectly reflected the urban spirit of Punk/ New Wave. And it was not enough just to wear it. Between surfs, they spent long hours in Quiksilver's warehouse designing their own custom boardshorts.

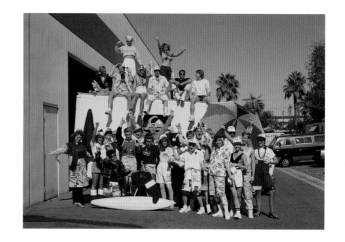

Surfboard design, too, enjoyed a renaissance. Lance Collins's box-rail Wave Tools twin fins melded perfectly with Echo Beach's tight pockets. Greg Pautsch's teardrop-shaped McCoy Lazor Zap single fins liked to be slashed under the lip. Shawn Stussy's sleek needle-noses spent many a Kodak moment in 56th Street's swishing right tube. Peter Schroff's twin fins had a sculptural, fine art appeal.

A nondescript industrial district in Costa Mesa became a hive of creativity, with seminal shapers and designers all working within a few square blocks. It was like Montmartre in the early 1900s, albeit with foam dust, Day-Glo. Bottom curves were dreamed up over pancakes at Cappy's Cafe. Denim ranges were sketched out on cocktail napkins at the Tiki Bar.

Quiksilver dress-up party, circa early eighties.

In the summer of 1980, Quiksilver hosted the Echo Beach Challenge. Teaming up ace locals with Top 16 pros like Shaun Tomson, Rabbit Bartholomew, Cheyne Horan, and Simon Anderson, it was held on a hot, sunny weekend in gorgeous, overhead surf. Between the dazzling performances in the water, stunning women on the sand, and a flurry of photographers along the shoreline and on the jetties, Echo Beach looked like the greatest show on earth.

But not everyone was buying it. When the Echo kids surfed outside the 92663 zip code, they were ridiculed for their clownlike ensembles. While introducing a surf film at a Quiksilver function in low-key Santa Barbara, Kwock was heckled off the stage. "When the final standings are on the board," said 1976 world champion Peter Townend, "it's going to show that these guys haven't really done anything."

Most deflating was a piece written by future *X-Files* creator Chris Carter. Featured in a 1981 issue of *Surfing*, "Newport Beach: Too Many Pictures Tells the Story" called Kwock and crew out:

> *The bottom line in the saga of Newport Beach is that the instant rocketing to stardom of getting your picture in the magazine has led to not only warped values and perspectives in the surfing world, but sort of a laziness and complacency among Newport's leading pros. Why travel and compete when you can become a star without leaving your own backyard? Few have traveled the circuit or, aside from flashes of brilliance, fared well competitively. Newport's amateur base is weak at best, and the attempts of the locals to set up a surf club have evaporated in a cloud of apathy and chaos; a case of too many chiefs and not enough indians. None of the top dogs have made any great efforts towards accepting the challenge of the eighties, which is to prove yourself against the world's best surfers on the pro tour.*

Bob McKnight and Danny Kwock, Quiksilver factory.

The Echo kids were undaunted. They were under no illusions about their talents. They were also running on borrowed time. In 1982 the first Op Pro was held at Huntington Beach, breathing new life into the California contest scene. In the mid-eighties, the video revolution hit hard, shifting the focus from magazines to VHS titles like *Blazing Boards*, *The Performers*, and *Wave Warriors*. Kwock took an office job at Quiksilver. Parker took up breakdancing. Echo Beach did not exactly end, but its heyday had passed.

The more surfing screeches into the accelerated future, however, the more ahead of its time Echo Beach appears. The way in which Kwock and crew blurred self-expression and self-promotion and thrust themselves into the spotlight was a portent of reality TV. The "photo surfer" vocation that they pioneered is now an industry standard.

And the list of achievements by the original Echo Beach players is impressive: Grassroots board builder Shawn Stussy would bring surf fashion to the streets. Richard Woolcott, a towheaded fifteen-year-old at the height of the Echo era, would launch Volcom. Richie Collins, 1989 Op Pro Champion, would silence anyone who ever said that Echo Beach kids were all hype. Danny Kwock would initiate the signing of eighteen-year-old Kelly Slater—surfing's first million-dollar contract. Quiksilver would go public in 1986 and become the first billion-dollar surf brand. Costa Mesa's tiny businesses would move into warehouses the size of airplane hangars, and multiply wildly, earning the nickname "Velcro Valley." Surfing would become ubiquitous.

But accolades are not the point. At its core, Echo Beach was about self-expression, resourcefulness, seeing a world in a 100-yard stretch of sand and water. Like the great punk rock motto says, "Here's three chords, now go form a band."

Jamie Brisick

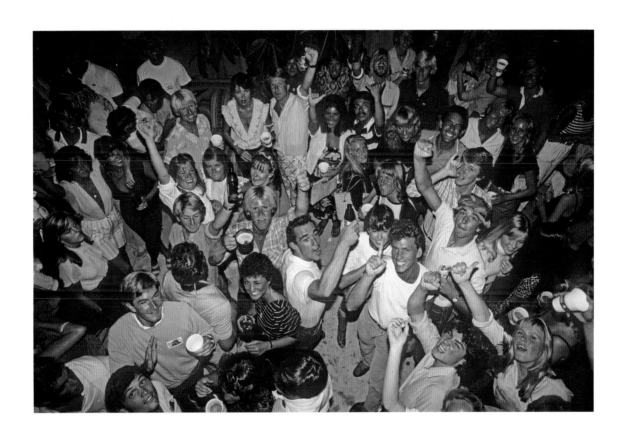

Cheyne Horan's birthday bash. "It turned into a riot," remembers Jeff Parker.
"The cops showed up with billy clubs, there were punches thrown, people flying over walls. Totally out of control." (Photo: Chuck Schmid)

PHASE ONE 1979 – 1982

"I was sponsored by Quiksilver clothing, Rip Curl wet suits, McCoy surf-boards, and Newport Surf and Sport, and they would talk about how valuable advertising was. And I thought, 'Getting a photo in the magazine with someone's clothes on and their stickers on your board, that's kind of like advertising, right? Like race car driving.' I wasn't a business major; I was a high school dropout. But it was obvious that that had to be worth something." — Danny Kwock

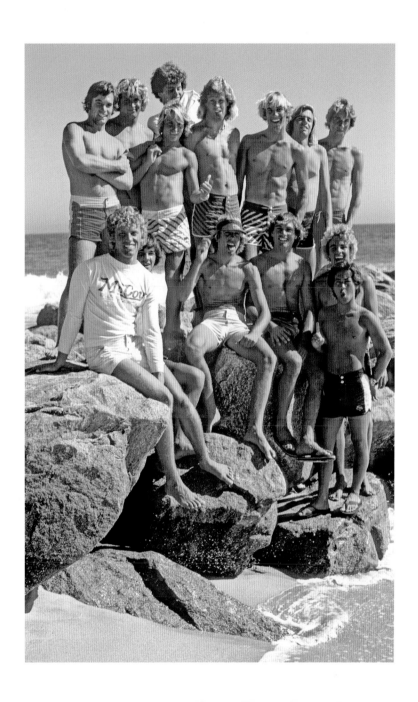

(L to R, top row) Dave Noel, Geoff Madsen, Alan Lopez, Andrew Coutts, Jeff Parker, John Gothard, Greg Hill, Nigel Kent
(L to R, bottom row) Craig Brazda, Ross Morgan, Preston Murray, Dorian Ronai, Rod Bell, Danny Kwock. (Photo: Chuck Schmid)

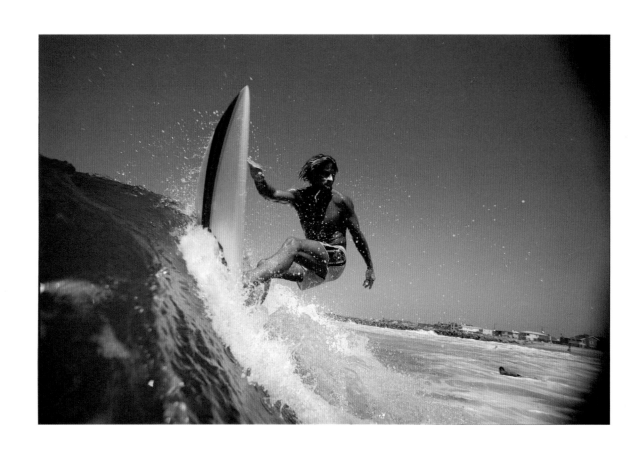

Geoff Madsen, summer smack.

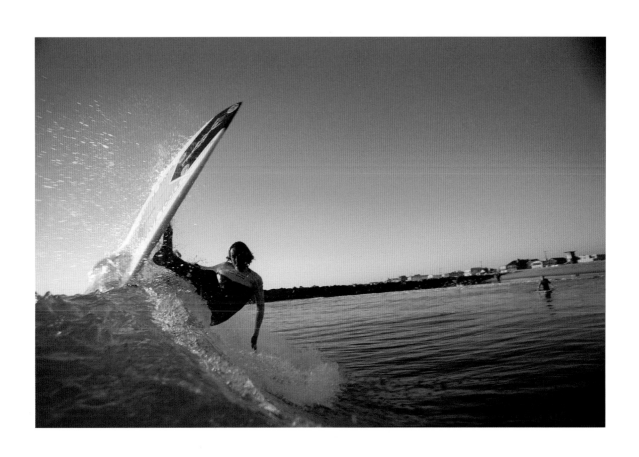

Preston Murray, winter crack.

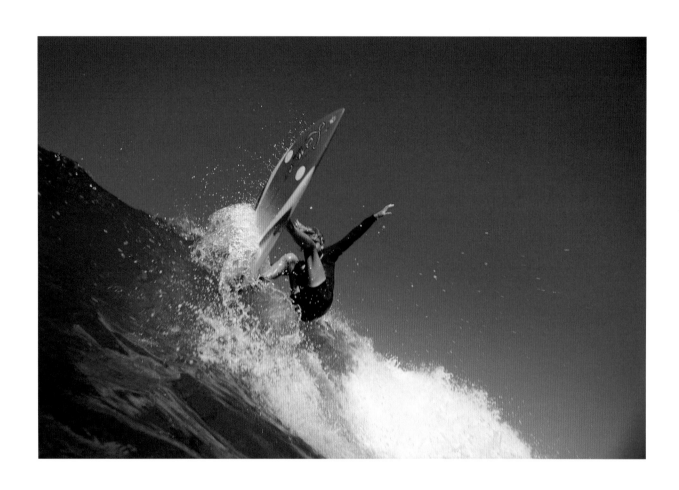

Richie Collins, ten-years-old in this shot, would go on to a hugely successful career in pro surfing.

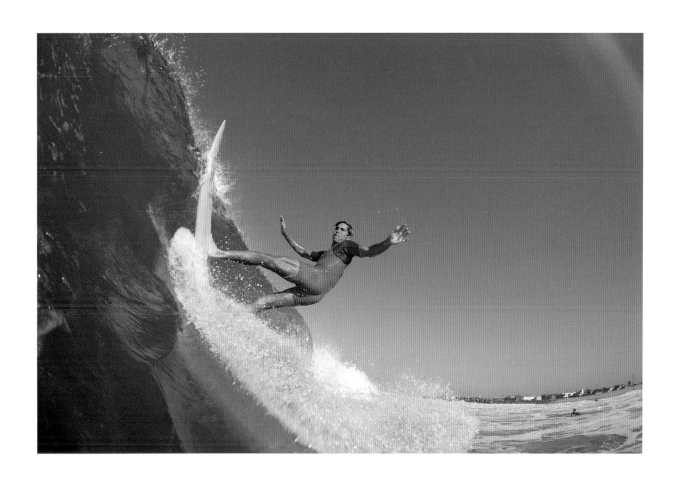

John Gothard, hot pink at the behest of his sponsors, would go on to a long and fruitful career in the surf industry.

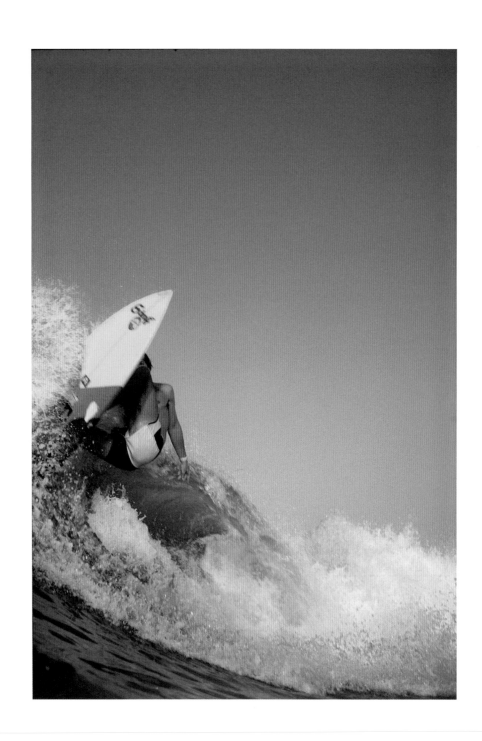

Hugh Johnson, banging and slashing. Johnson was a test pilot for shaper Peter Schroff's innovative twin fins.

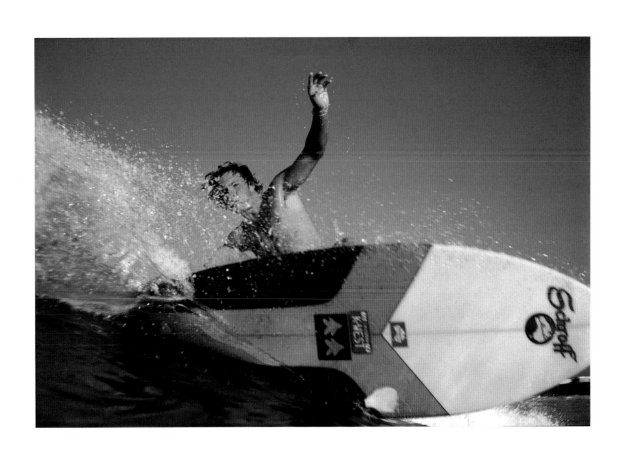

He was known as "Newport's Rabbit," after Aussie Rabbit Bartholomew.

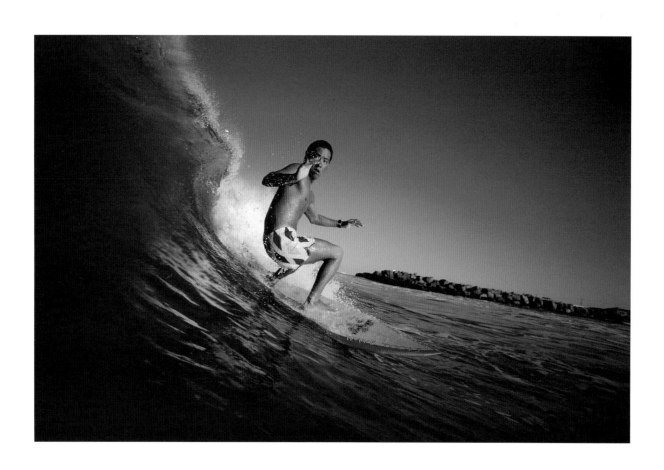

"The impact of life hadn't yet kicked in," remembers Danny Kwock (L and R). "We lived in the moment—right here, right now."

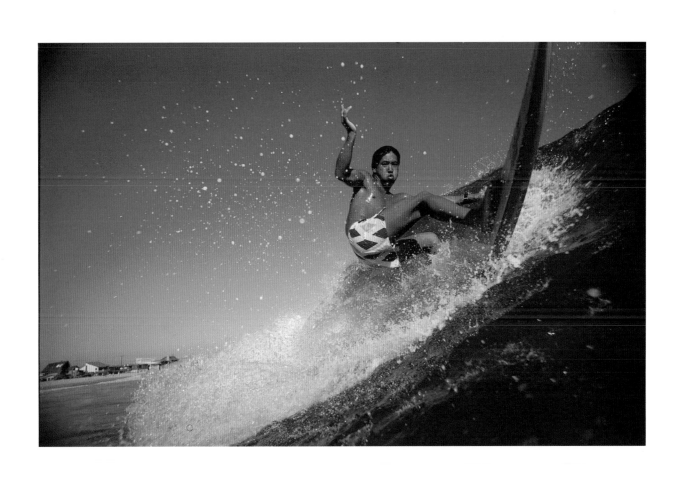

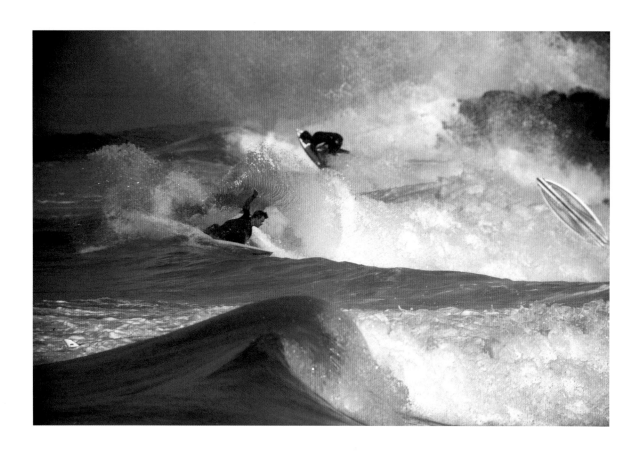

Dave Parmenter, carving out his own path amid the chaos. Parmenter wanted nothing to do with the Echo Beach scene.
When the cameras came out, he'd paddle down the beach.

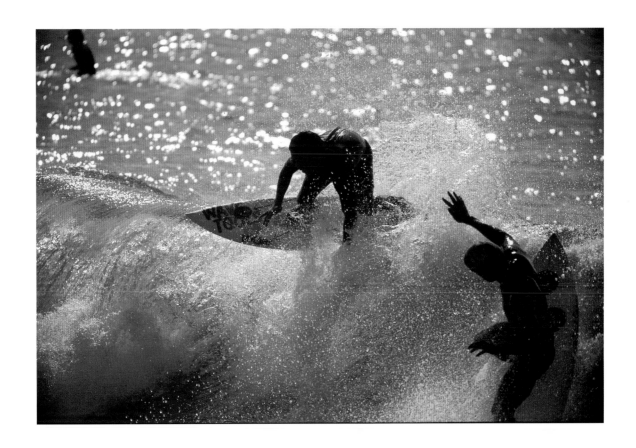

Richard Knight follows Danny Kwock's lead. While the jetties did wonders for the surf, they also funneled in the crowds. Not a single wave was wasted.

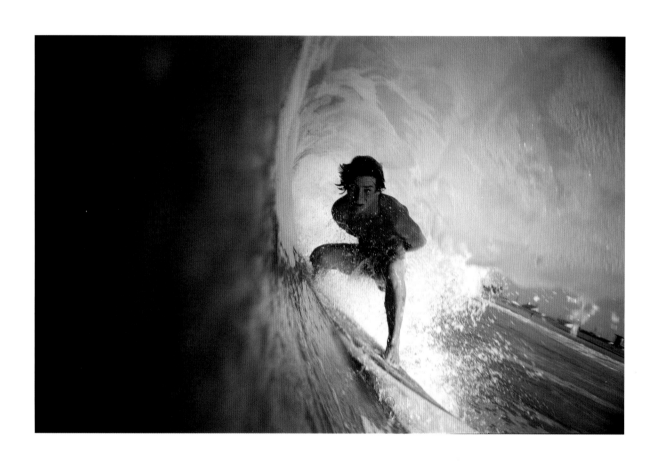

Alan Lopez, a moment of rapture amid the mayhem of summer.

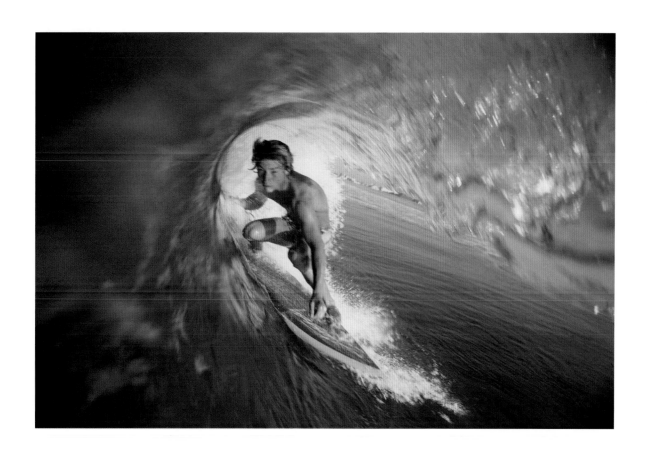

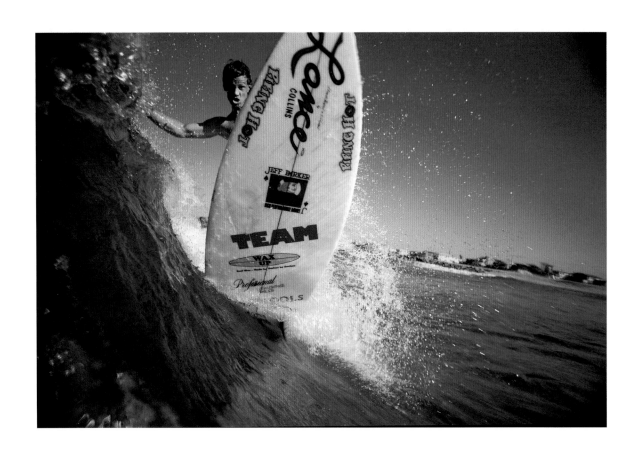

"We were between formats," remembers Jeff Parker (L and R). "Surf movies were at a low point, and VHS hadn't kicked in yet.

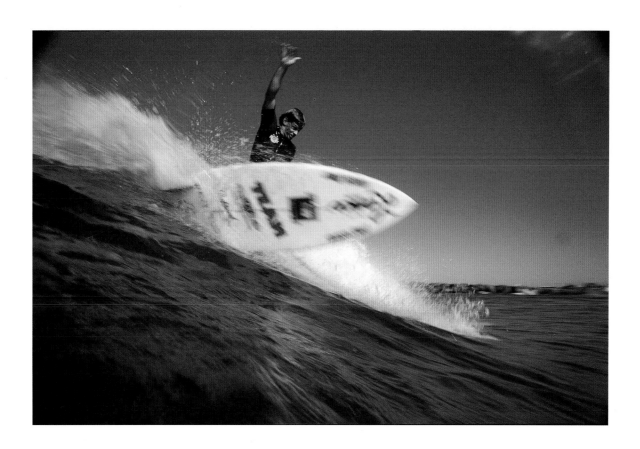

Surf magazines were the main source of media—to be a surf star you had to get your picture in the mags. We were in the right place at the right time."

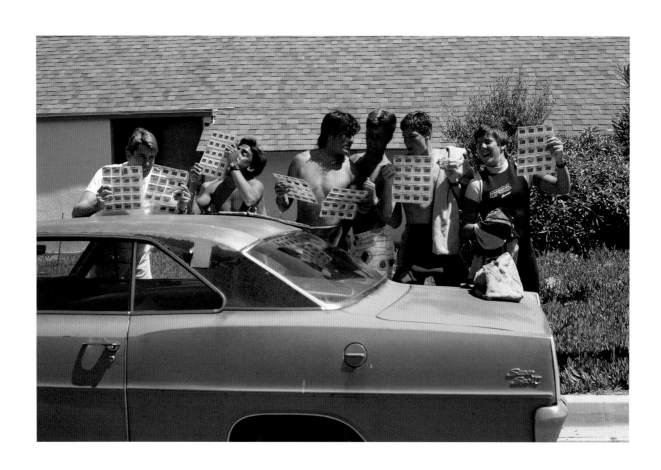

"There would be ten or fifteen photographers shooting at the same time," remembers Jeff Parker.
"And the cool thing was that we could buy the B-shots off the photogs for our portfolios."

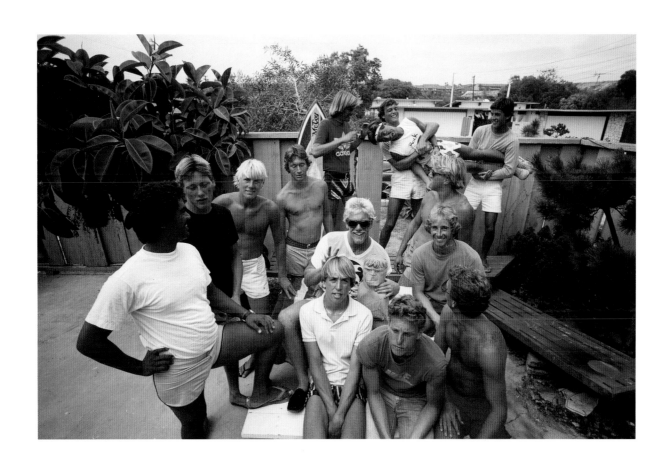

Echo Beach was accused of being incestuous, but in fact it was a kind of way station for traveling pros. Aussies visited frequently, as did Hawaiians.

Aussie shaper Geoff McCoy and his American counterpart Greg Pautsch, 1982.

Craig Brazda, one of McCoy's hottest team riders.

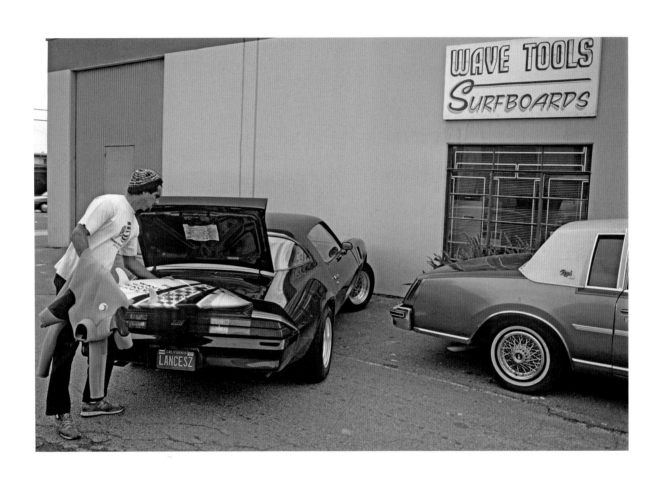

Lance Collins, founder of Wave Tools surfboards, loads up his Z. (Photo: Chuck Schmid)

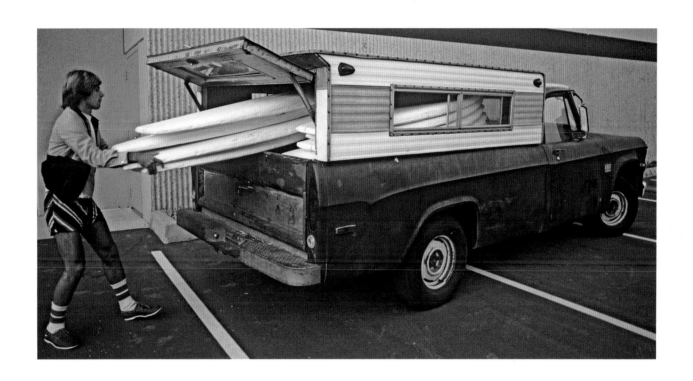

Bob Hurley, unloading blanks to shape at the Wave Tools factory. (Photo: Chuck Schmid)

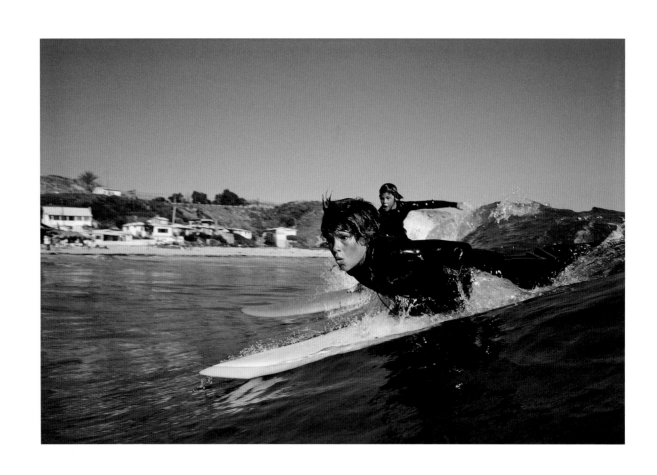

Brothers Mike and Dave Estrada at Crystal Cove, Corona del Mar, in the summer of 1979.

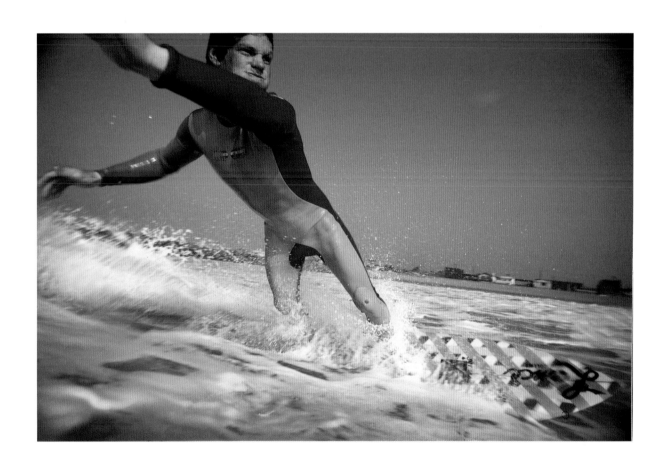

"It took a while for all that hair spray to melt," remembers Jeff Parker. "And when it did melt, it would drip into your eyes and burn."

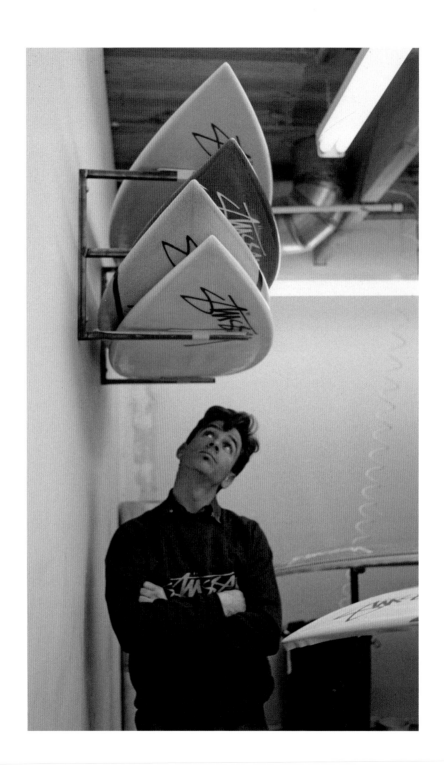

Shawn Stussy's first love was shaping surfboards. But it was his clothing label that would launch him to world renown. (Photo: Chuck Schmid)

Likewise Peter Schroff, who started as a surfboard shaper but went on to become a highly touted artist and designer.

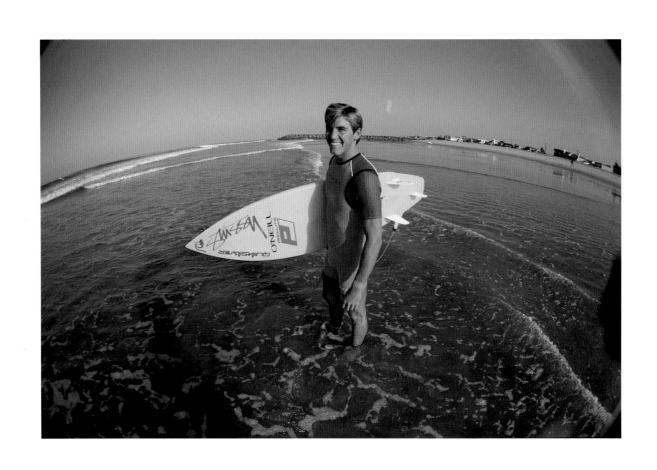

A glowing John Gothard.

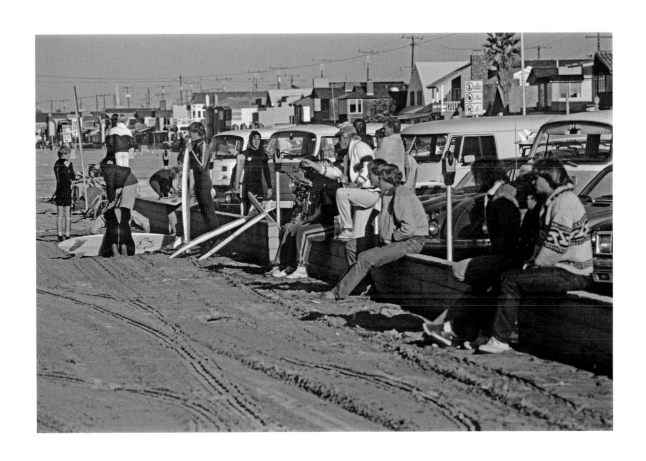

A packed Blackie's parking lot. (Photo: Chuck Schmid)

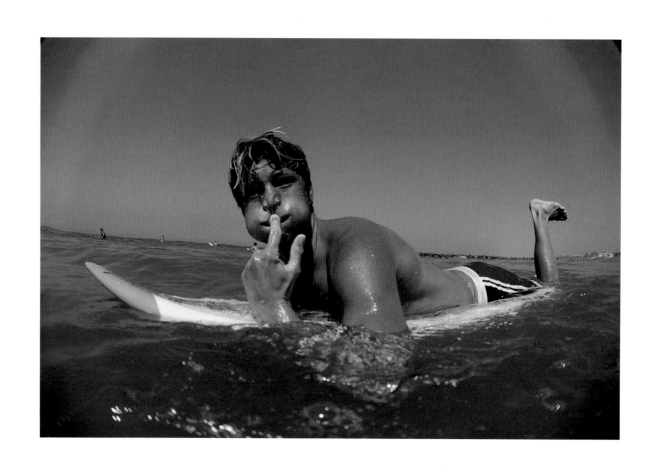

Brad Gerlach, hamming.

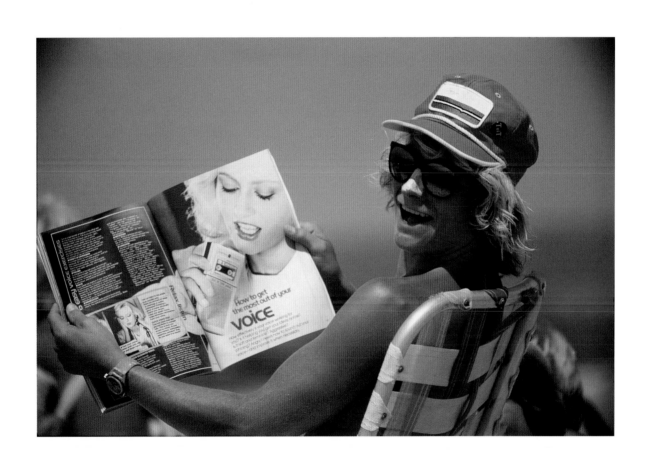

Alan Lopez, scoping.

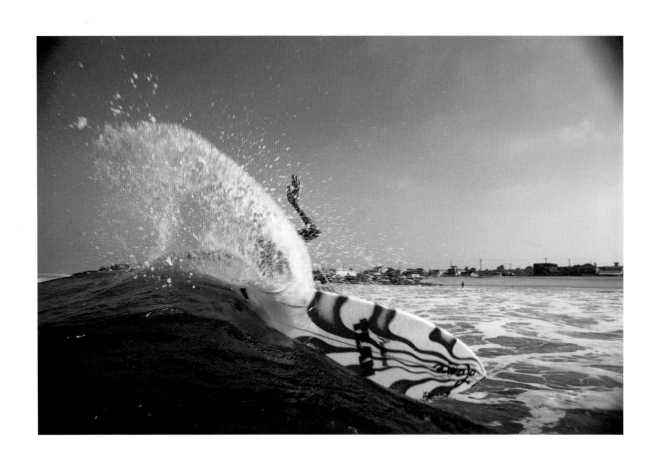

"Echo Beach was more artistic expression than athletic expression," remembers Preston Murray. "Everyone was ready for it."

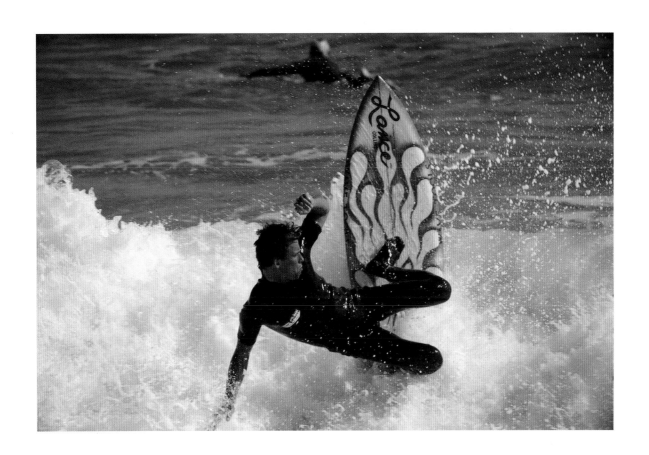

"Craig Brazda was incredibly limber," recalls photographer Mike Moir. "He would contort his body into wild positions and somehow recover."

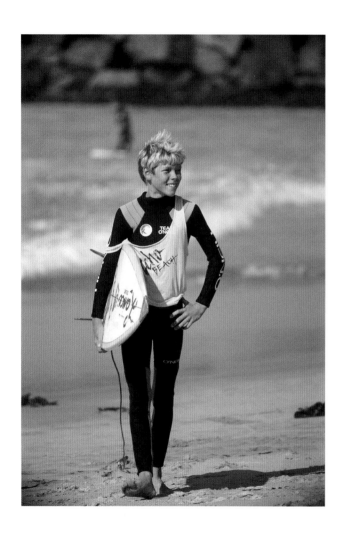 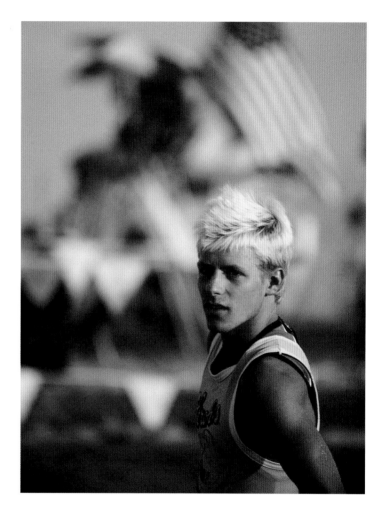

(L) Richie Collins, Echo Beach Challenge. (R) Richard Woolcott, 1984 World Contest. In 1991 he would found Volcom.

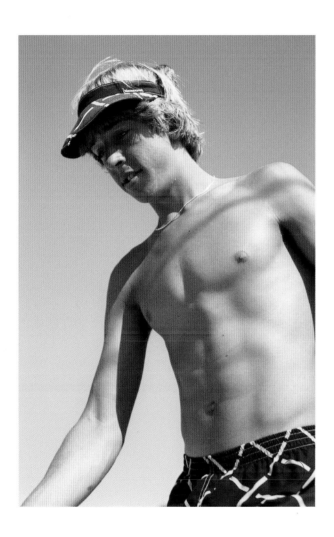
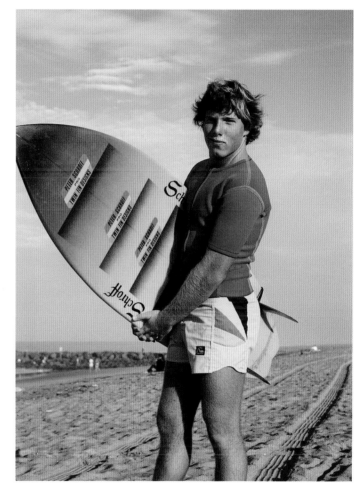

(L) Preston Murray steps up to receive his trophy at the Echo Beach Challenge. (R) Hugh Johnson, summer of 1982.

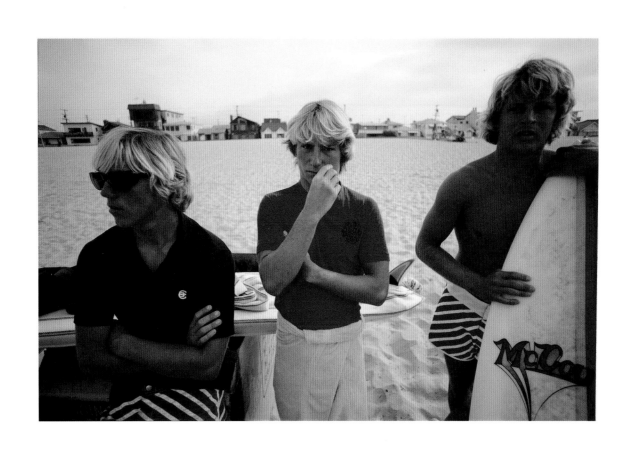

John Gothard, Alan Lopez, and Geoff Madsen in an uncharacteristically quiet moment at Echo Beach.

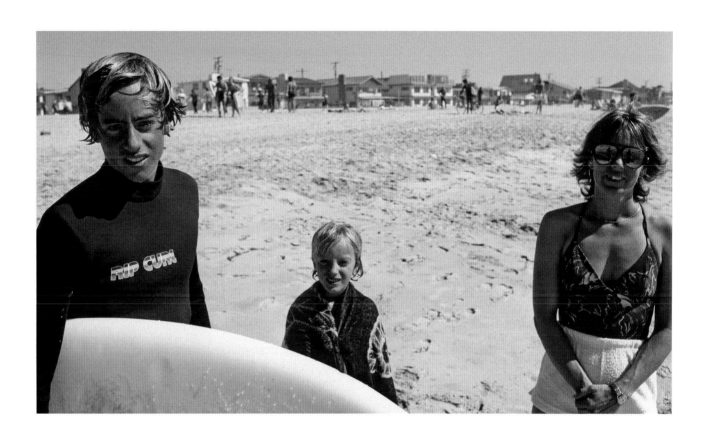

A teenage Tom Curren, with brother Joe and mother Jeanine. Curren's humble, low-key approach was a far cry from the Echo ethos, but nonetheless he was dazzling in the fast, zappy waves of Newport Beach. (Photo: Chuck Schmid)

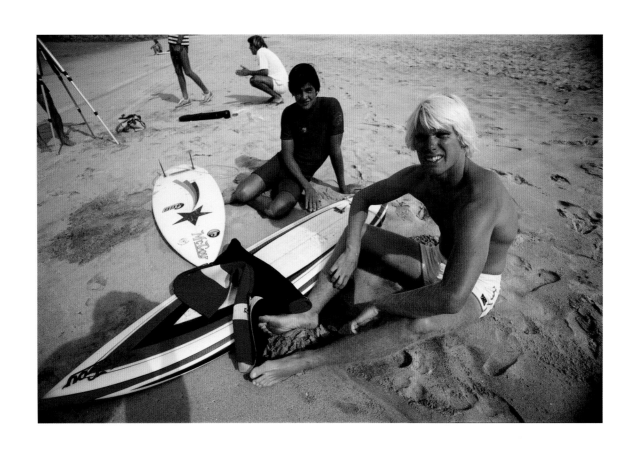

McCoy team riders (L) Ross Morgan and (R) Julian Eymann.

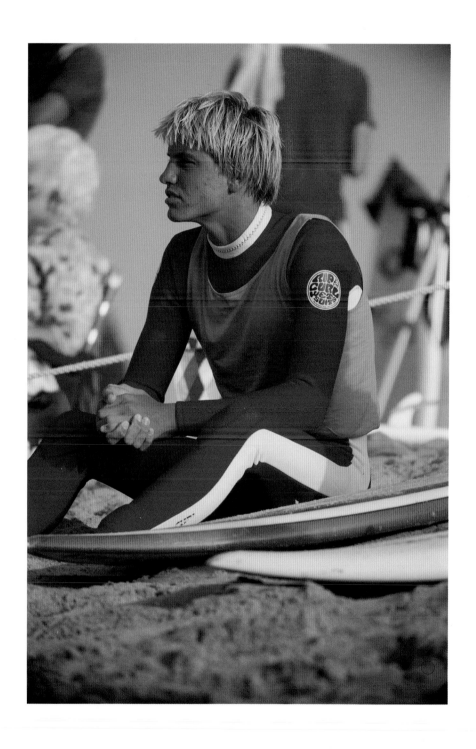

Hermosa Beach's Chris Frohoff psyches up for the finals of the Echo Beach Challenge.

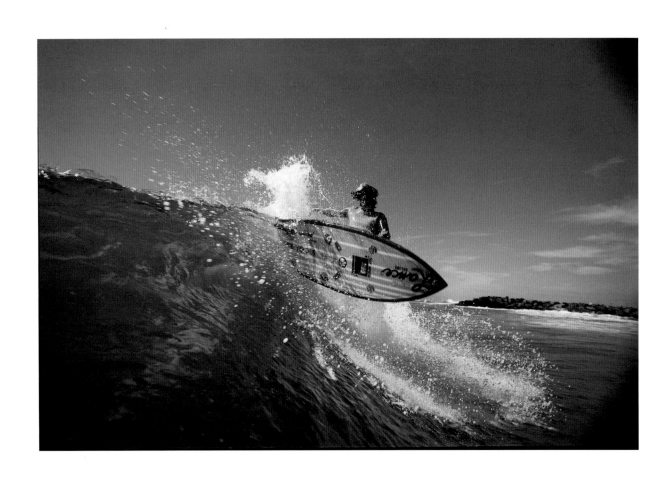

Jeff Parker slashes.

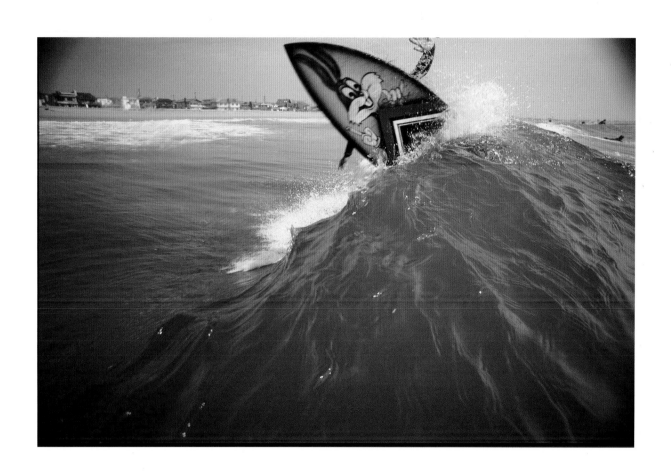

Pat Allen bashes.

Danny Kwock and his girlfriend, Jody, reveling in the summer of 1980.

The much adored Cheyne Horan on his birthday night. (Photo: Chuck Schmid)

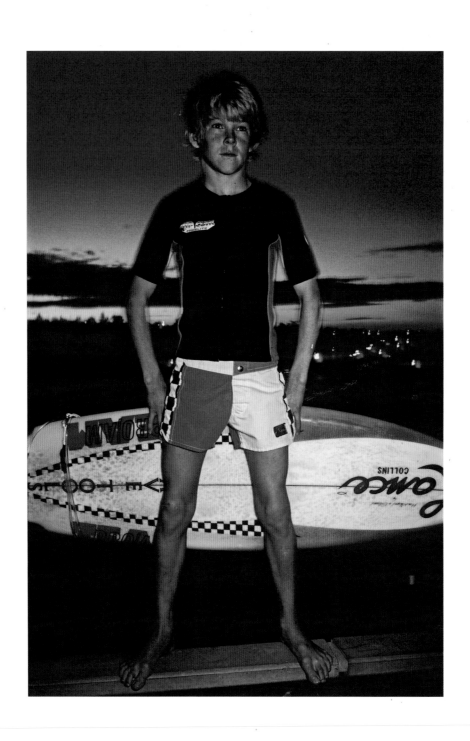

Newport Beach's Richie Collins. (Photo: Chuck Schmid)

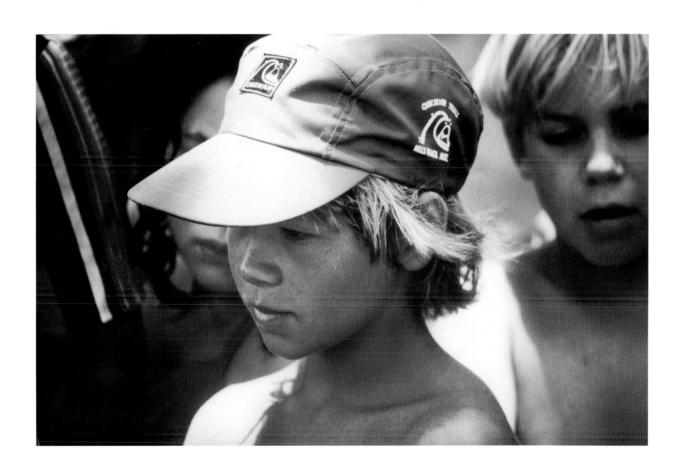

Laguna Beach's Jeff Booth. Both Booth and Collins would do major damage on the ASP world tour. (Photo: Bob McKnight collection)

A Newport lifeguard starts his workday, oblivious to the Budweiser-wrapped surfer sleeping atop his tower.

Sandy was her name. She didn't know a cutback from an off the lip, but nonetheless she incited twirls and back flips from Echo Beach's dancing seals.

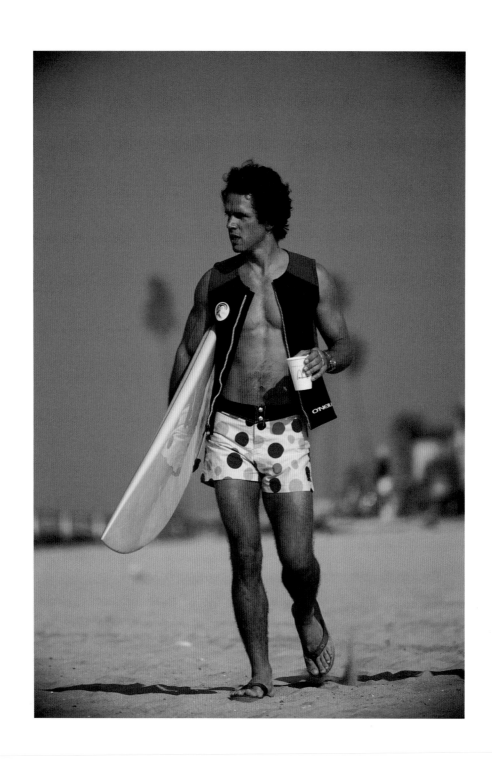

Actor Gregory Harrison, aka "Gonzo" on *Trapper John, M.D.*, was an Echo regular.

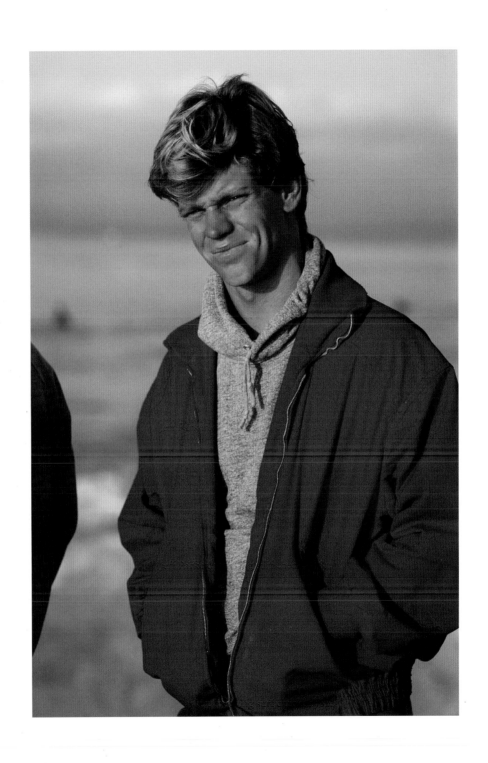

Jeff Parker, morning surf check, 1981.

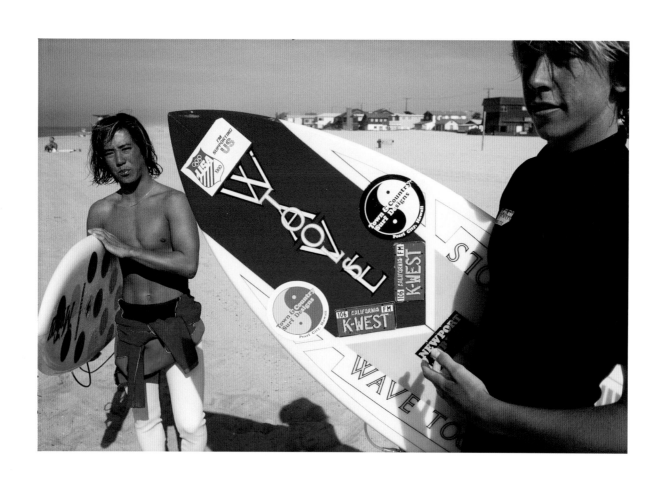

Danny Kwock and Preston Murray, 1979.

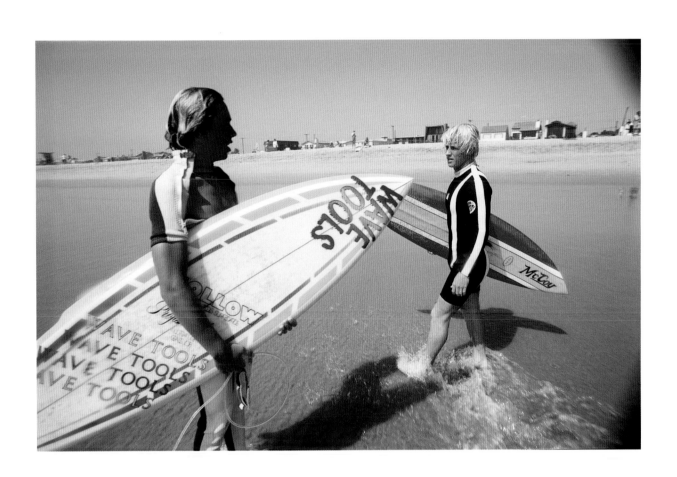

Preston Murray and Cheyne Horan, 1981.

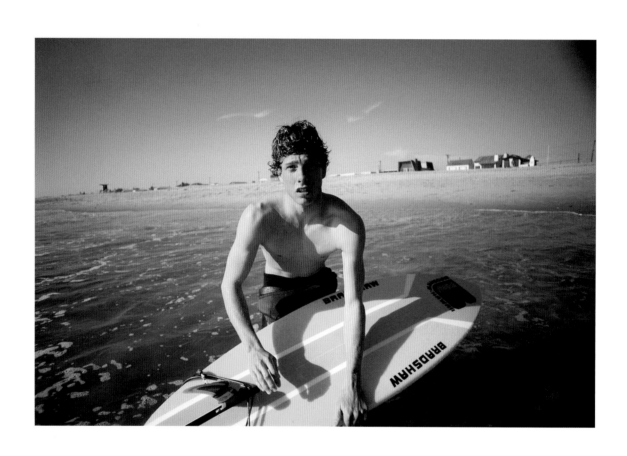

Unanimously hailed as one of the finest surfers of the period, Steve Richardson drew crisp, smooth lines.

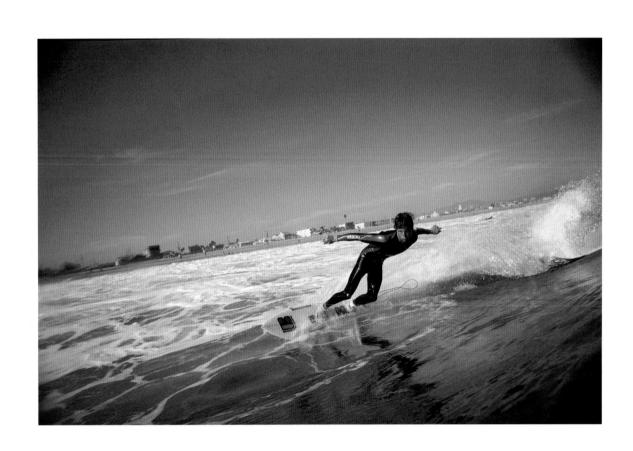

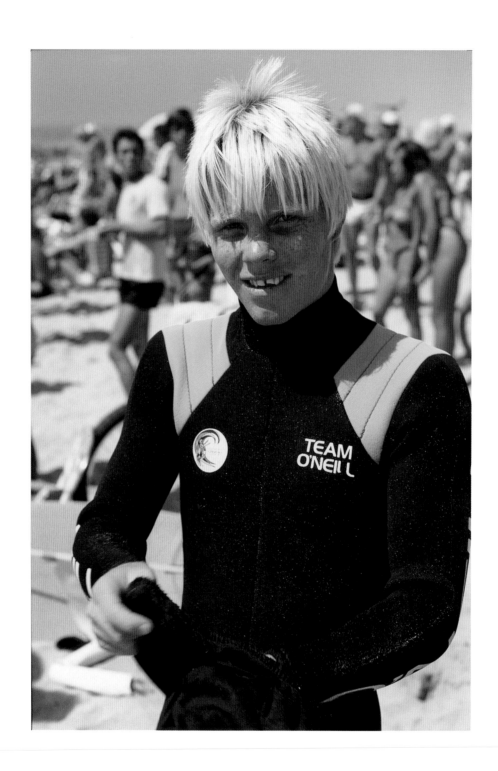

(L) Smerk Mangan and (R) Doug Silva, pre-heat at the Echo Beach Challenge.

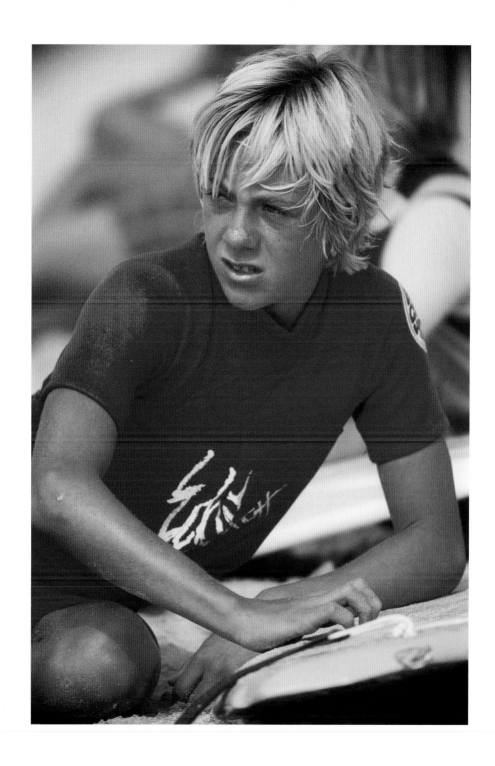

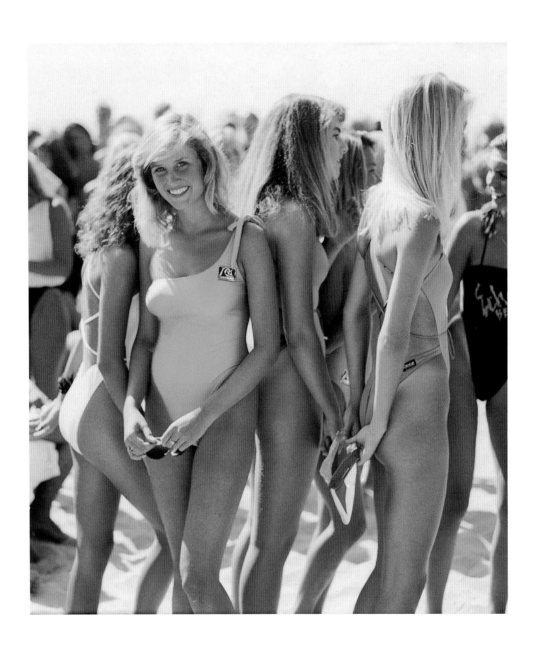

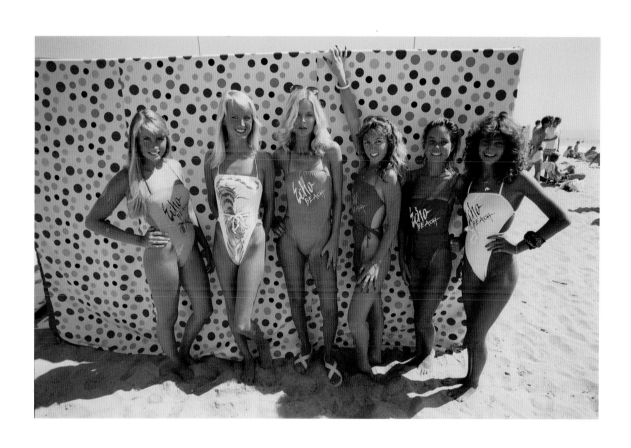

Echo Beach swimsuit contest.

(L) Craig Brazda, (R) Julian Eymann, and friends.

Mickey Neilson with sandwich and friends. (Photo: Bob McKnight collection)

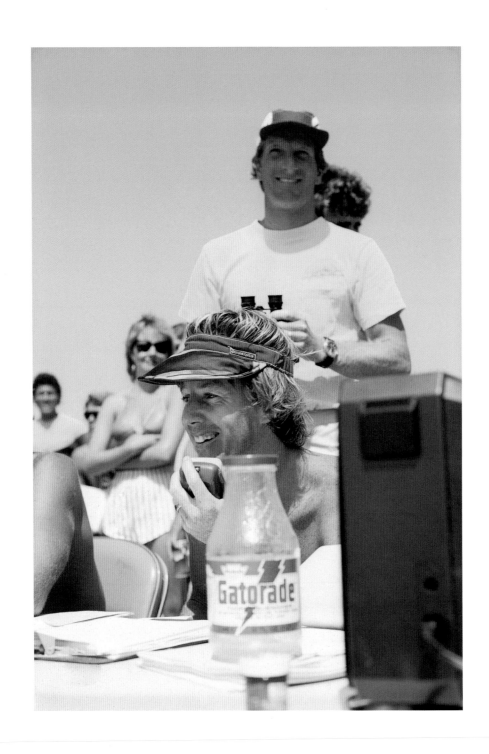

Rabbit Bartholomew (front), 1978 world champion, added colorful commentary to the Echo Beach Challenge.
Quiksilver president Bob McKnight (rear) doubles as spotter.

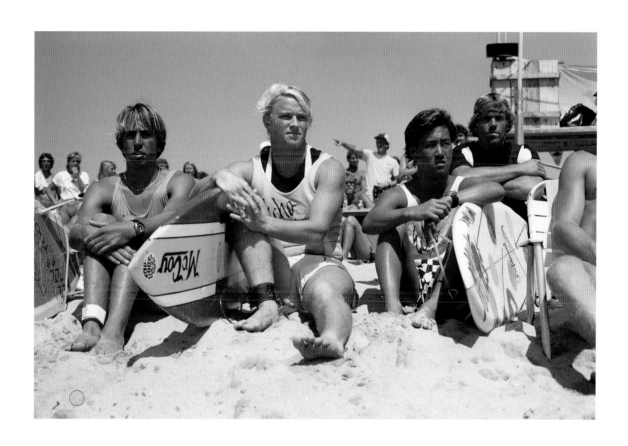

(L to R) Preston Murray, Cheyne Horan, Danny Kwock, and J Riddle study the surf before the Echo Beach Pro final.

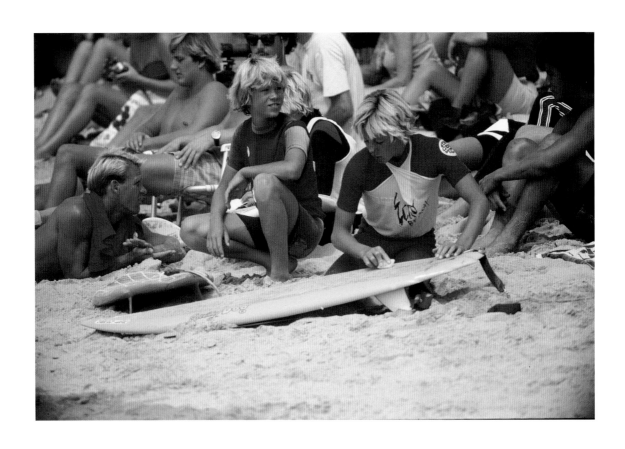

Jeff Booth and Doug Silva prepare for battle in the Juniors final.

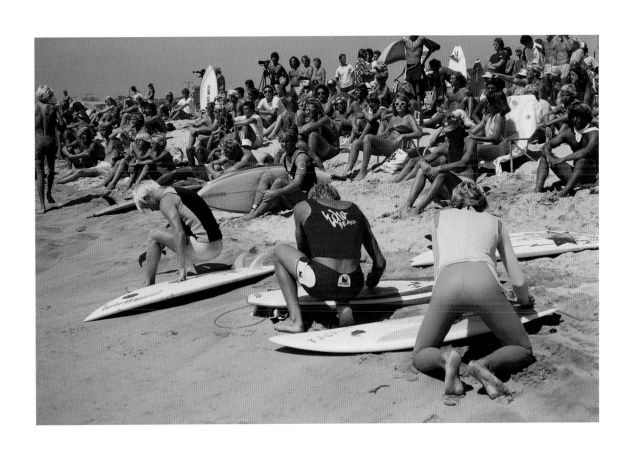

Men's Champion Chris Frohoff, flanked by Smerk Mangan (L) and Kelly Gibson (R).

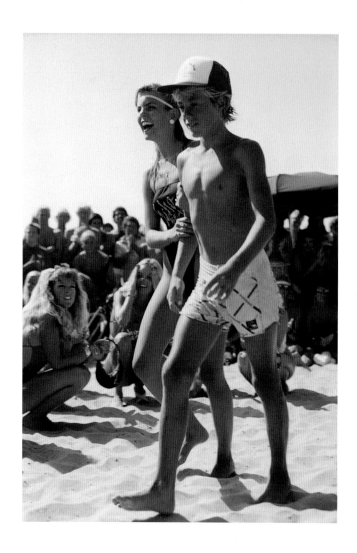
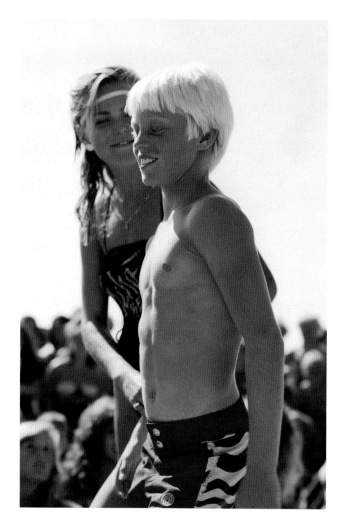

Like little Vanna Whites, the Echo Beach bikini girls escorted finalists up to the podium to get their trophies.

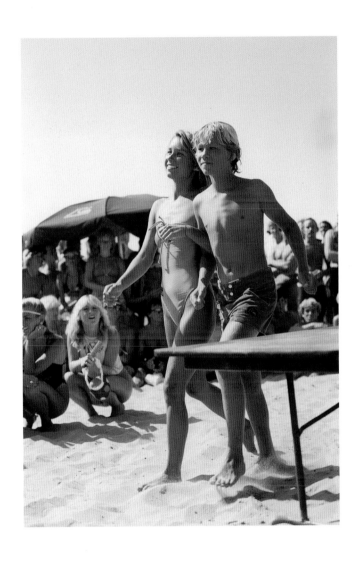

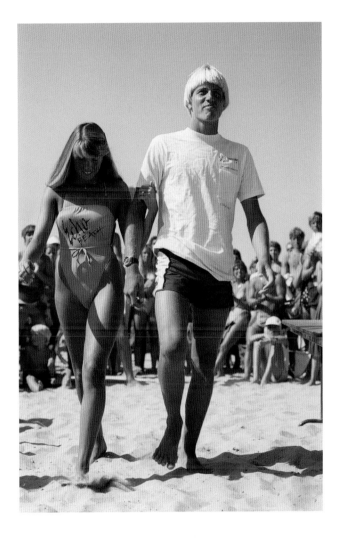

(L to R) Doug Silva, David Eggers, Jeff Booth, and Chris Frohoff.

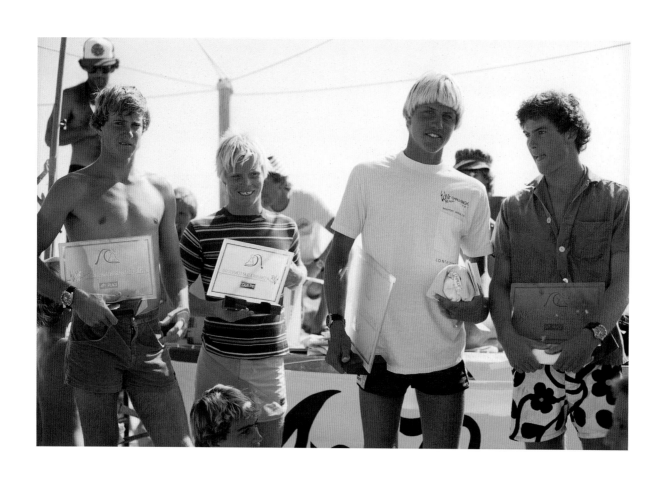

The Men's finalists (L to R): Chas Wickwire, Smerk Mangan, Chris Frohoff, and Marty Hoffman.

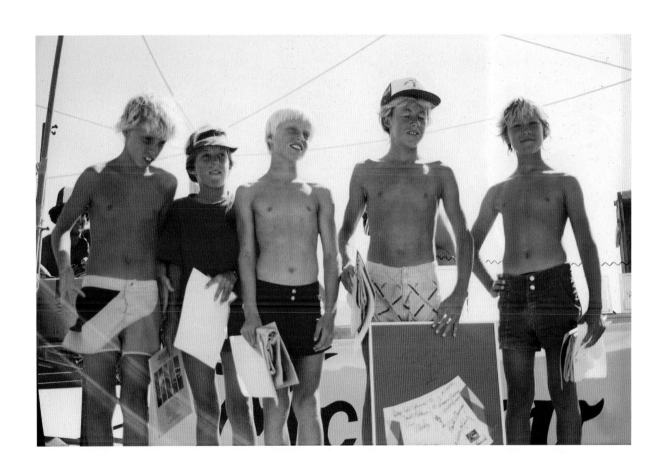

The Junior's finalists (L to R): Eric Jennings, unidentified, David Eggers, Doug Silva, and Jeff Booth.

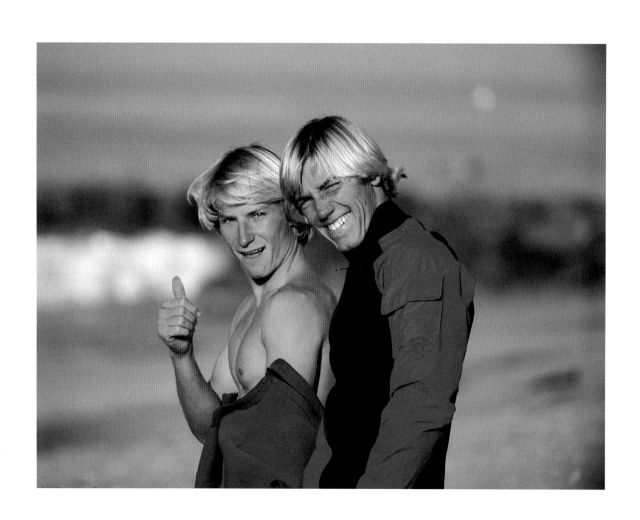

Stussy team riders Alan Lopez and John Gothard, 54th Street.

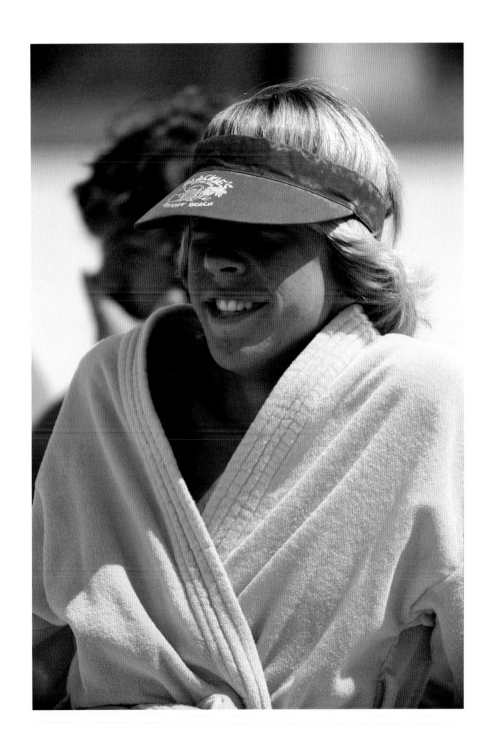

Preston Murray often strutted the sand in bathrobe with bowl of cereal in hand.

Malibu's J Riddle, between heats at the Echo Beach Challenge.

Amid checks, stripes, and towheads, Newport's Don Craig and Paul Heussenstamm survey the scene.

"Hey little sister who's your Superman?/Hey little sister who's the one you want?/Hey little sister shot gun!"
Brad Gerlach, evoking "White Wedding"–era Billy Idol.

"Black and orange stray cat sittin' on a fence/Ain't got enough dough to pay the rent/I'm flat broke but I don't care/I strut right by with my tail in the air!"
Jeff Parker, Stray Cat struttin'.

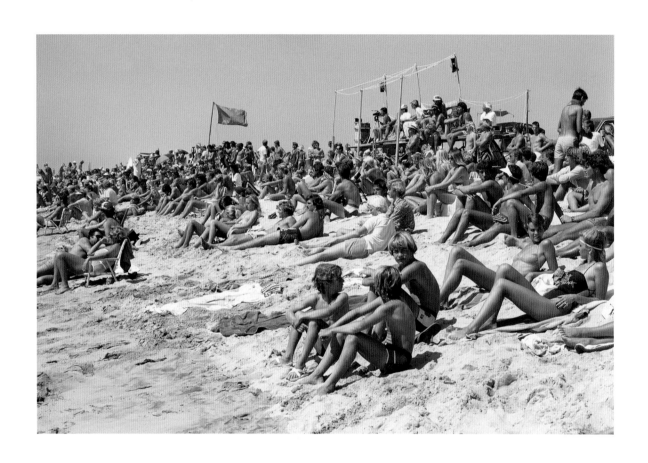

Two perspectives of the Echo Beach Challenge.

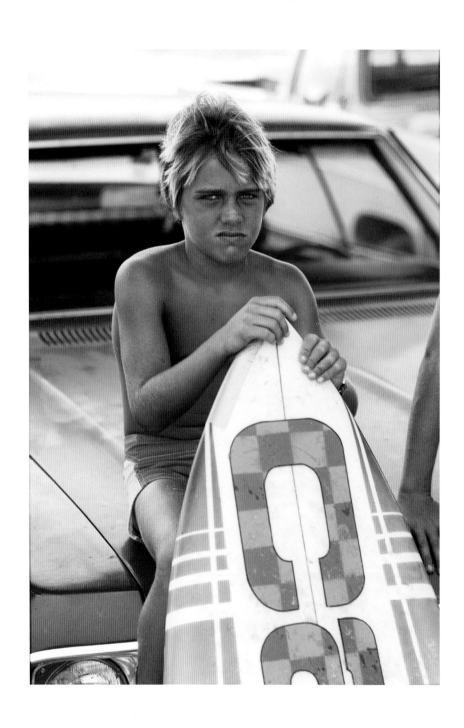

A ten-year-old Kelly Slater.

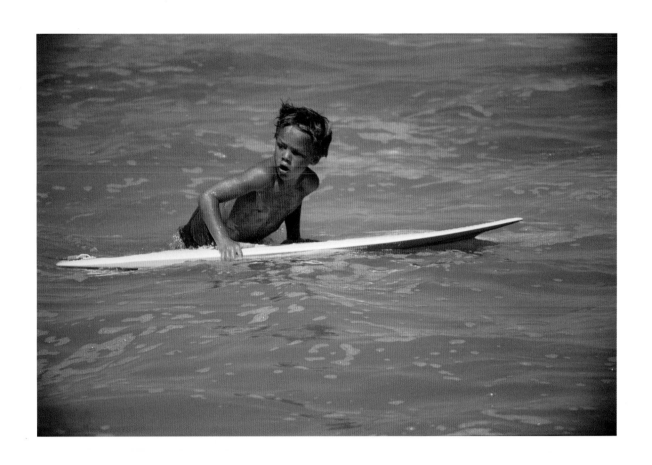

A six-year-old Nathan Fletcher.

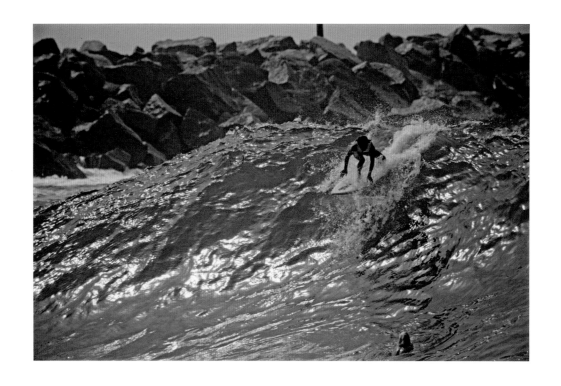

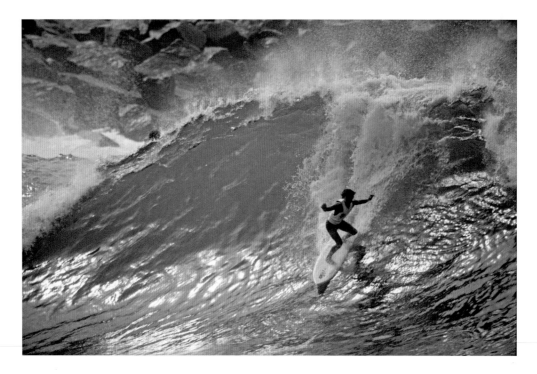

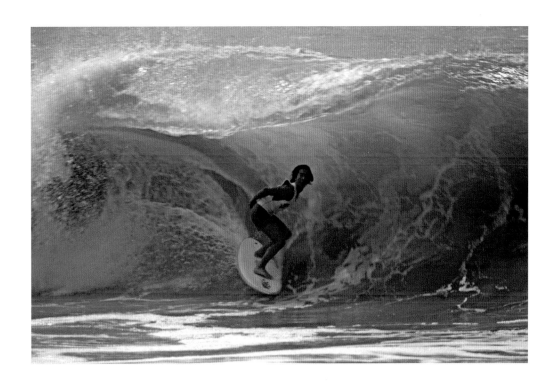

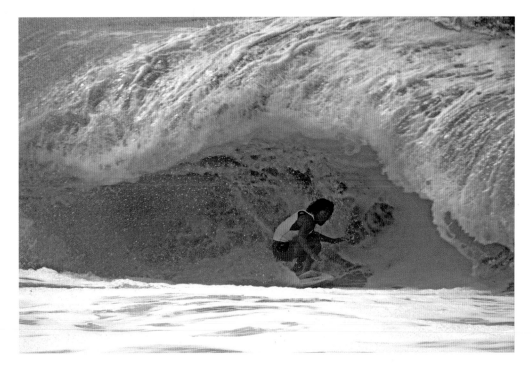

Danny Kwock, kamikaze barrel at his beloved Wedge. (Photos: Chuck Schmid)

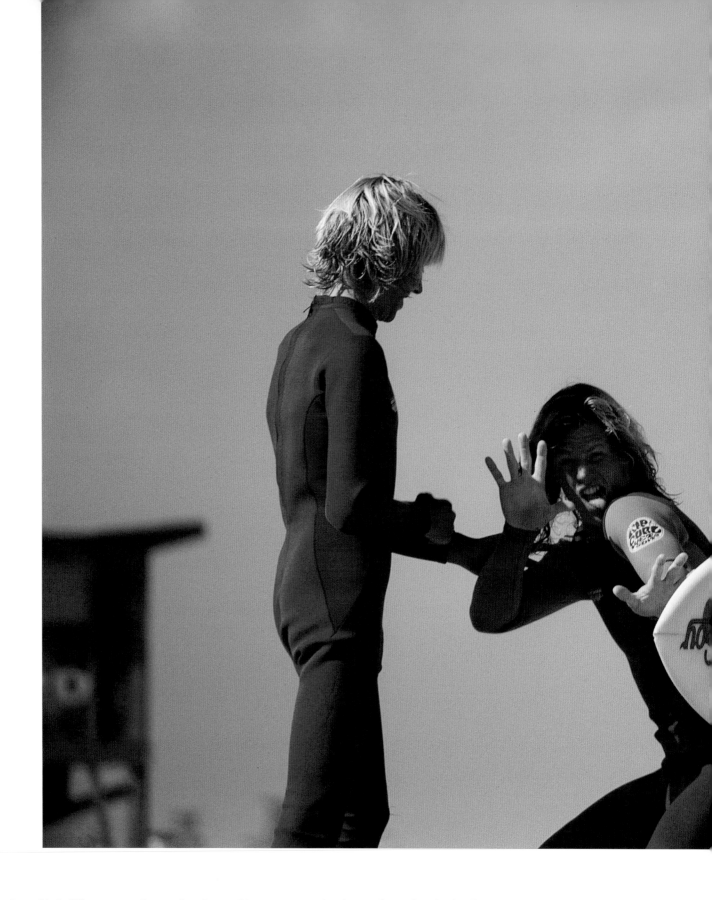

"Echo Beach was kind of like a summer," remembers Preston Murray. "It started with June gloom, then the sky cleared, the sun came out, and it was hot and firing for July and August. And then that day came in September when the wind had a certain chill, and we knew summer was coming to an end." (L to R) Preston Murray, Jeff Parker, and Danny Kwock, triumphant.

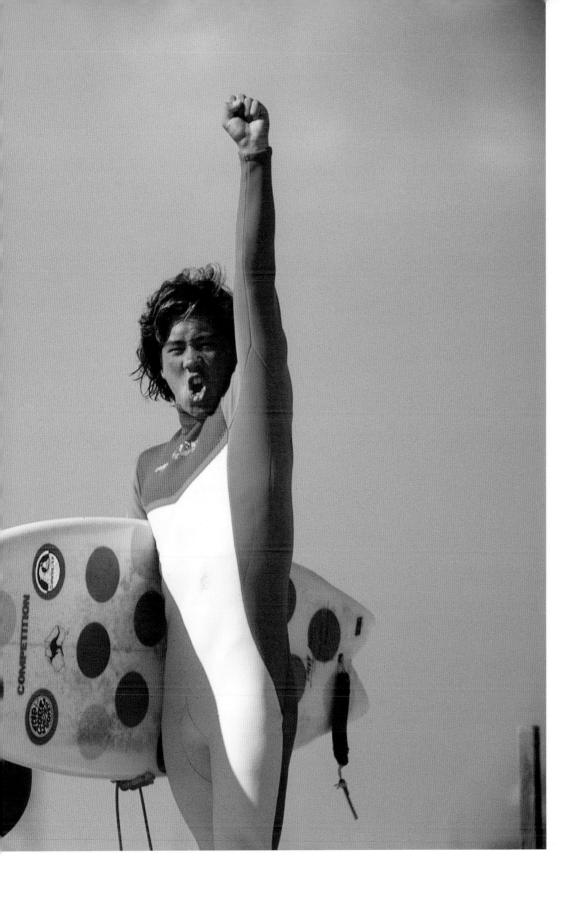

PHASE TWO 1985 – 1990

"If you grew up in Newport Beach in the eighties, the magazines weren't just some far-off brochure of surfing dreams. These were the real-life characters at your local beach. And growing up with them in the water around you, it was easy to detect all the flaws and scars that made these dudes up. When the guy you check the surf with every day wins the OP Pro and gets the cover of the magazine, it sort of makes it feel possible for you to do the same thing. And when the other guy you get coffee with each morning starts a little T-shirt business in his garage and it gets acquired by corporate America, you start to realize that these things are possible for you, too." — Matt Patterson

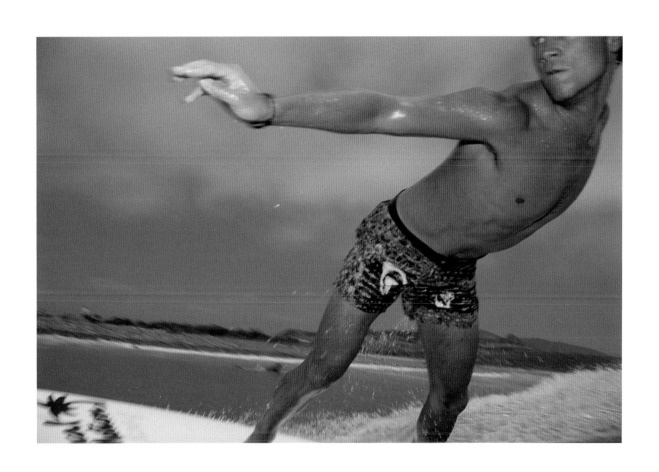

Jeff Booth, 25 miles down the coast at Trestles, 1989.

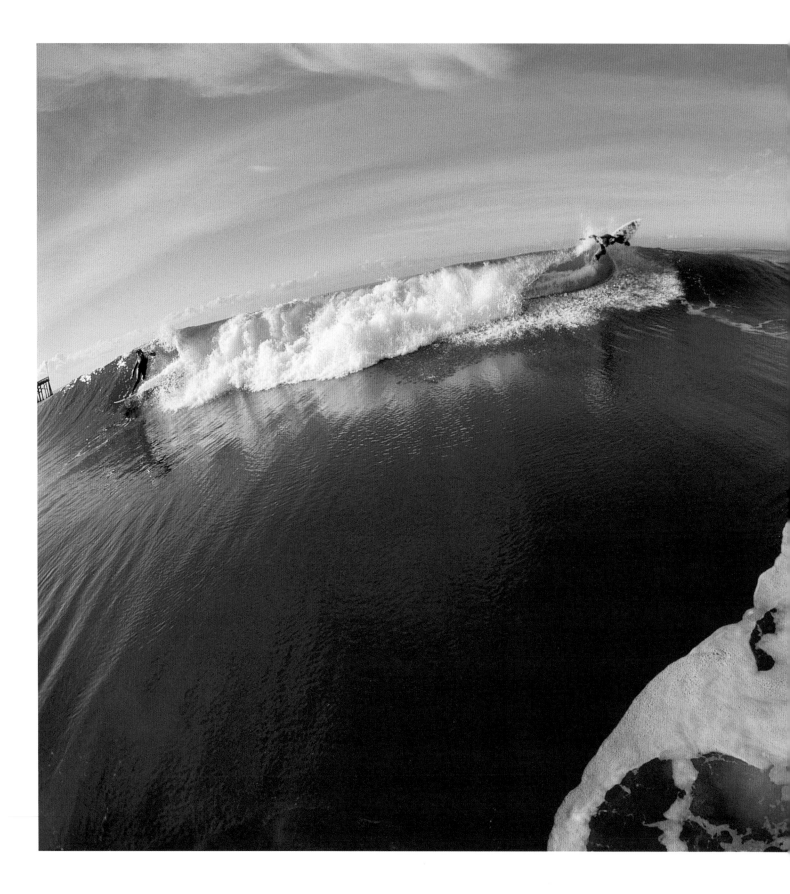

The son of Wave Tools founder Lance Collins, Richie Collins shaped his first board at age eleven and turned pro at age fourteen.

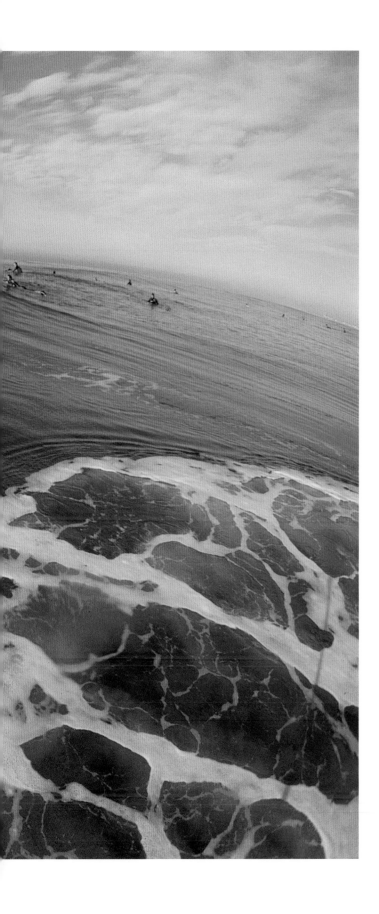

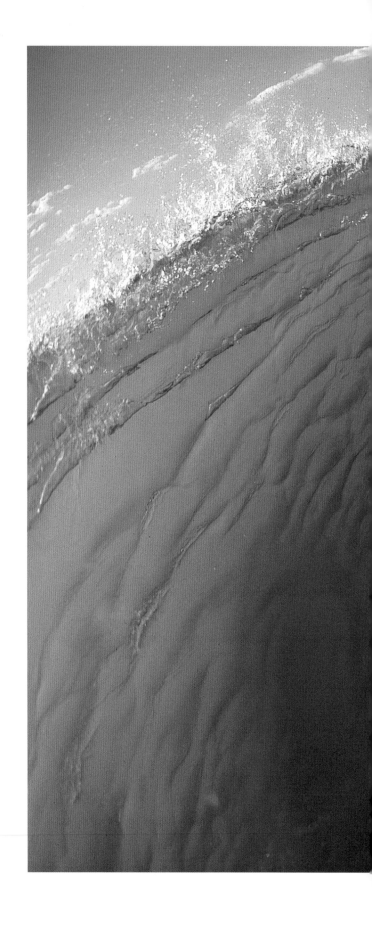

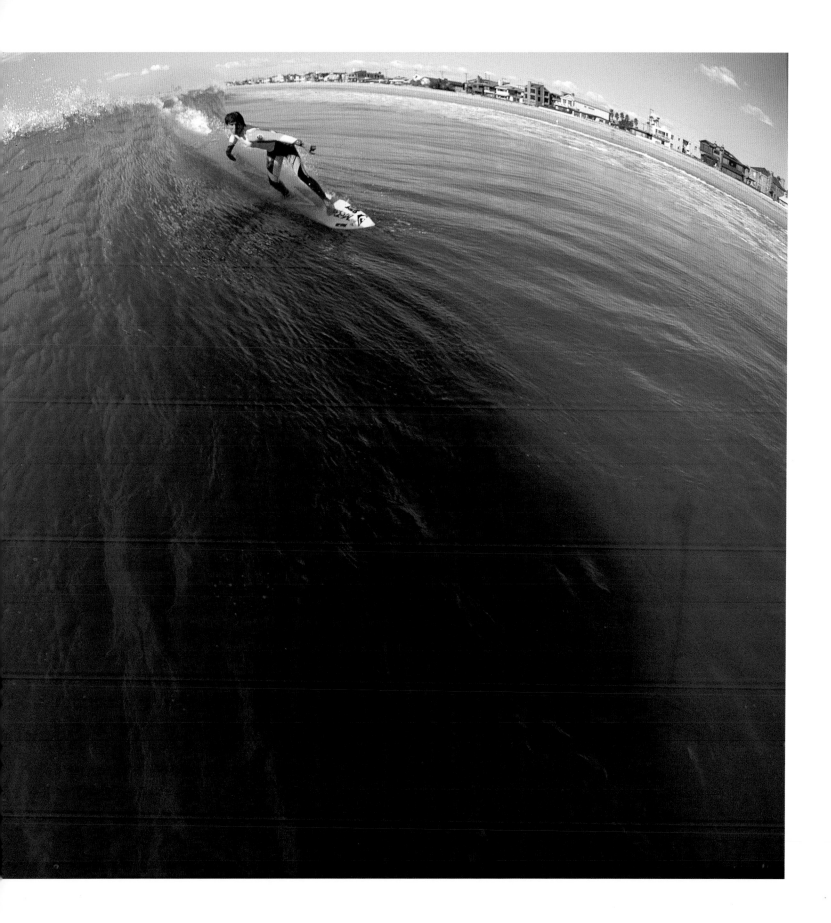

Robbie Todd, north side of 56th Street. "This was shot from a very early, very tall pole camera in 1987," says photographer Mike Moir.

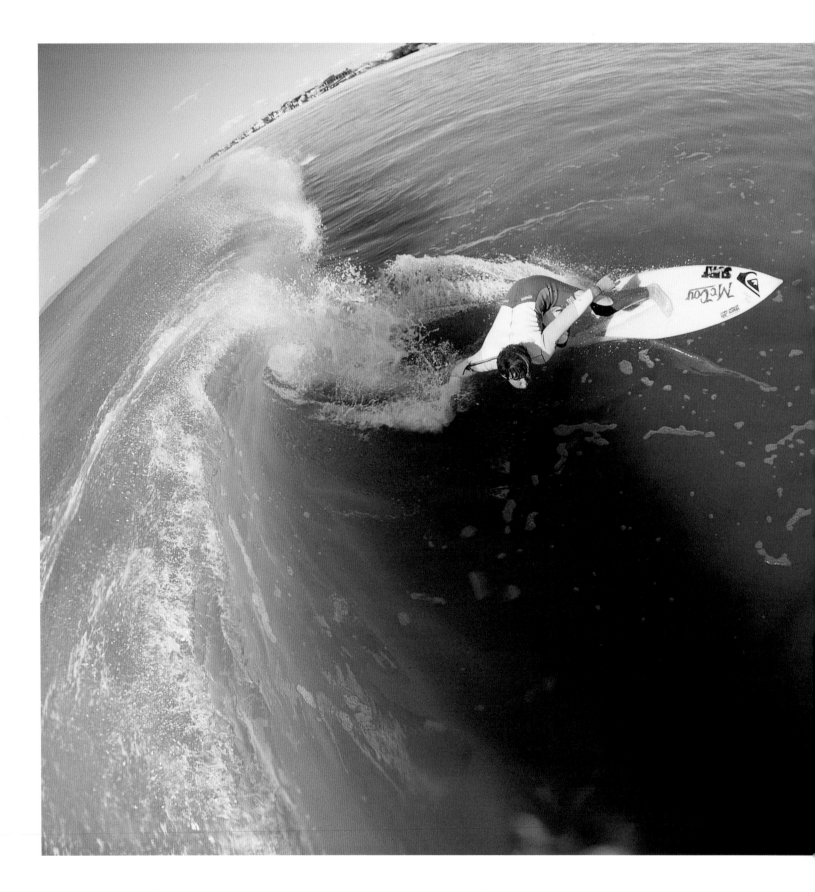

"Robbie Todd was one of my favorite surfers to work with in this second phase of Echo Beach," recalls photographer Mike Moir.
"He had a great flowing style and a great attitude."

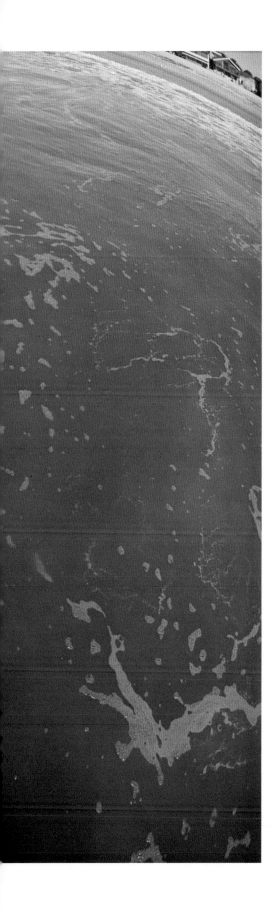

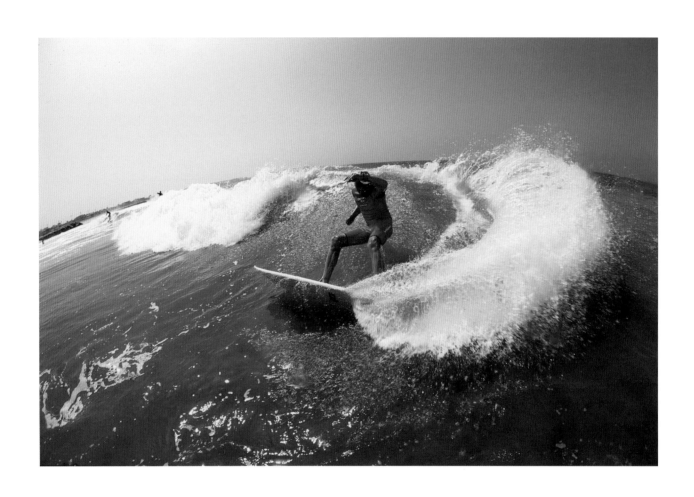

Same move, different angle: (L) Cordell Miller and (R) Todd Bousman.

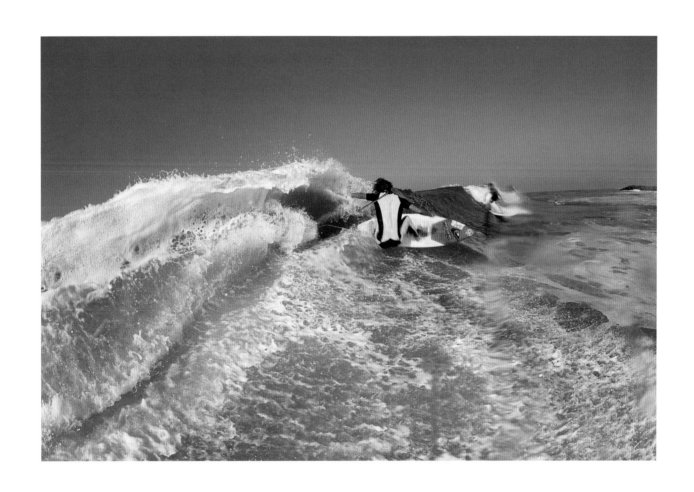

(L) George Hulse and (R) Matt Patterson were key figures in Echo Beach's second chapter.

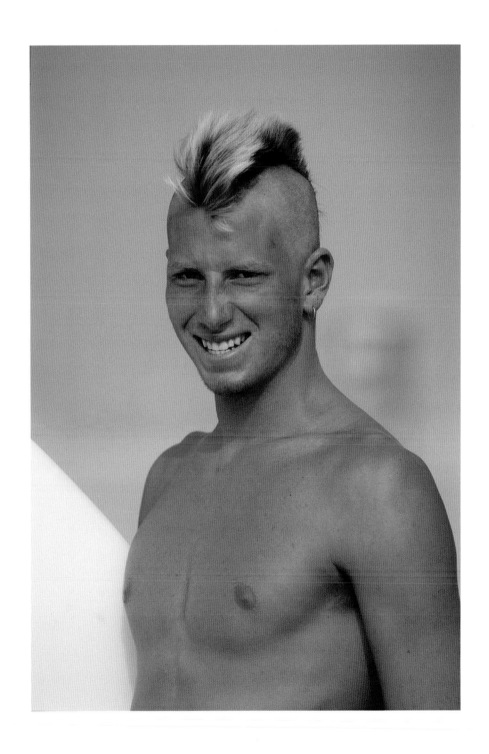

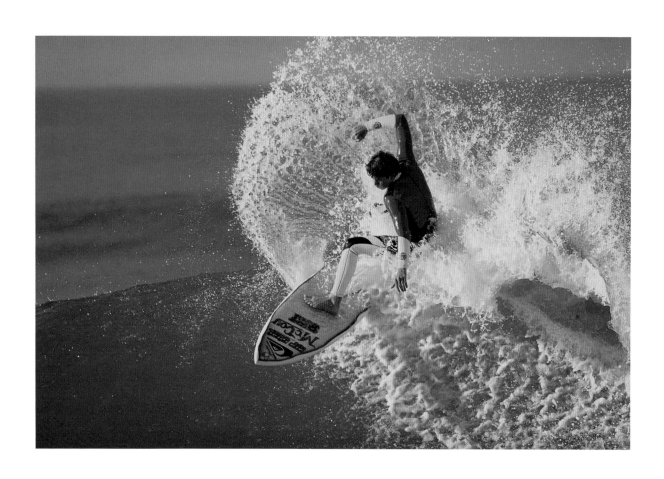

A logo-bedecked Robbie Todd cracks the corner.

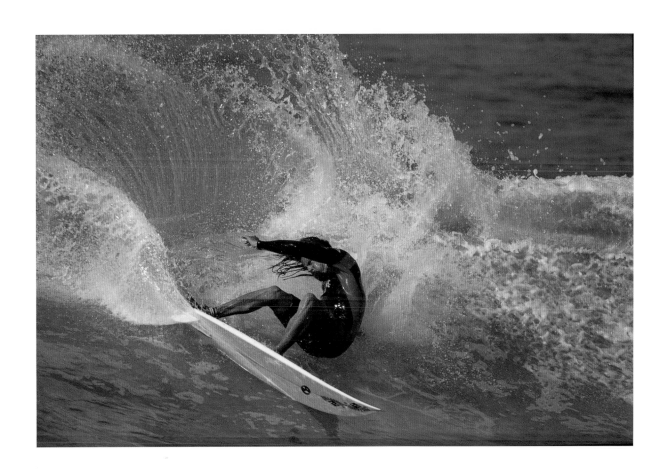

Donavon Frankenreiter, before the mustache and screaming groupies.

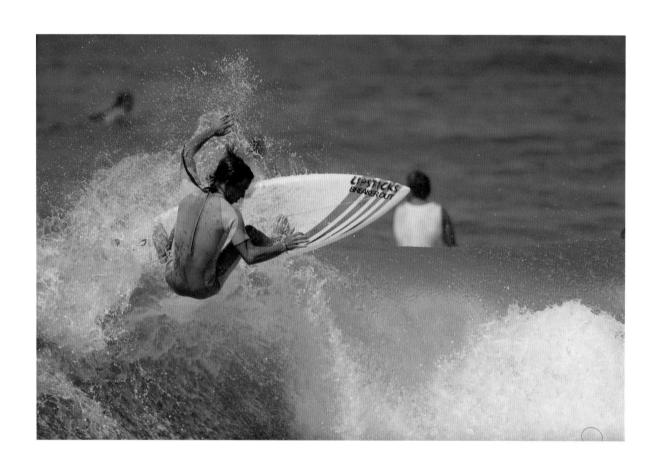

Short and bowly, with curling lips perfect for big kill moves, Echo Beach, aka "Kodak Sandbar,"
was like a photo studio. (L) Todd Bousman and (R) Ryan Simmons.

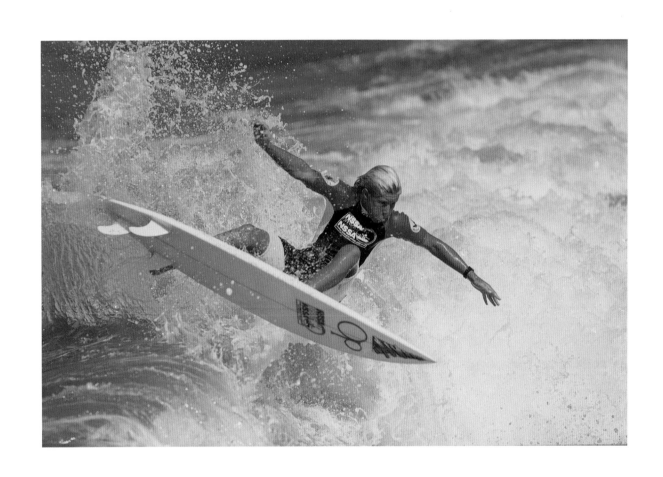

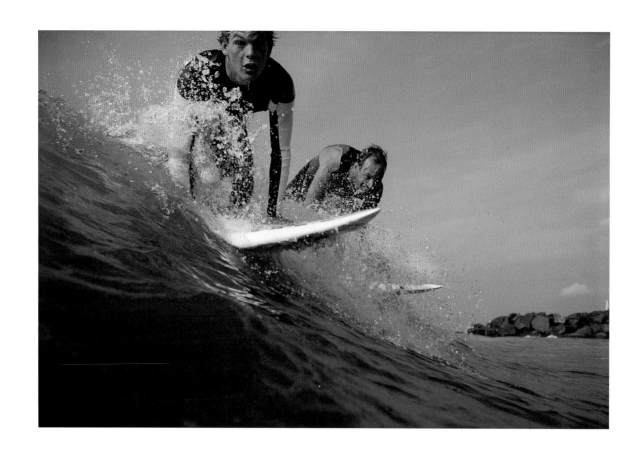

(L) George Hulse and (R) Peter Schroff share a wave. "To try and get work done out there in that crowd frenzy was no easy task," says photographer Mike Moir.

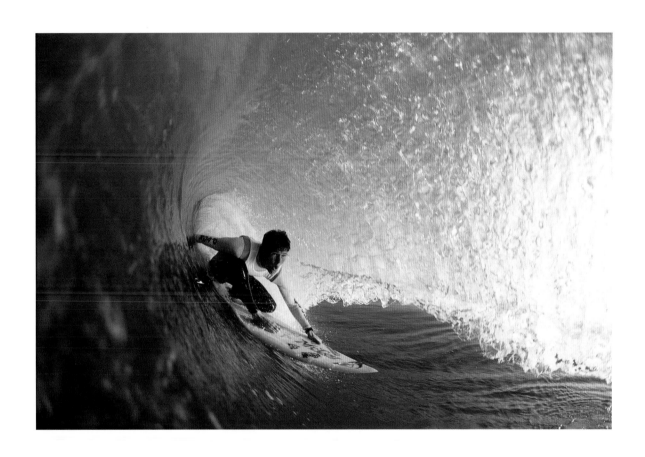

Mike Estrada, in a cocoon of spidery glass.

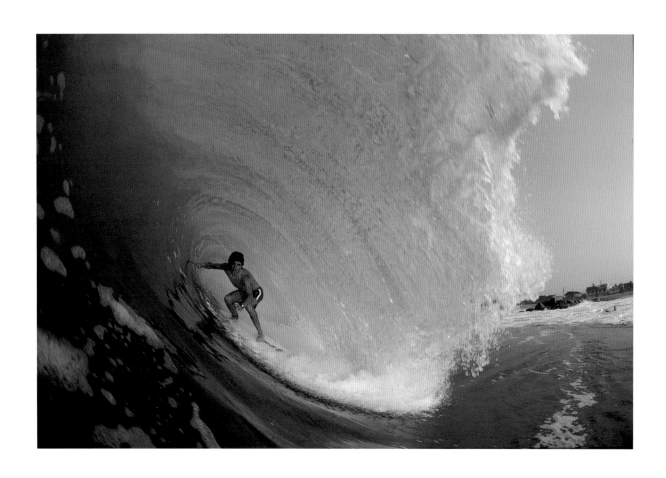

Hawaii resident Marty Thomas pulls in tight at 52nd Street in 1987.

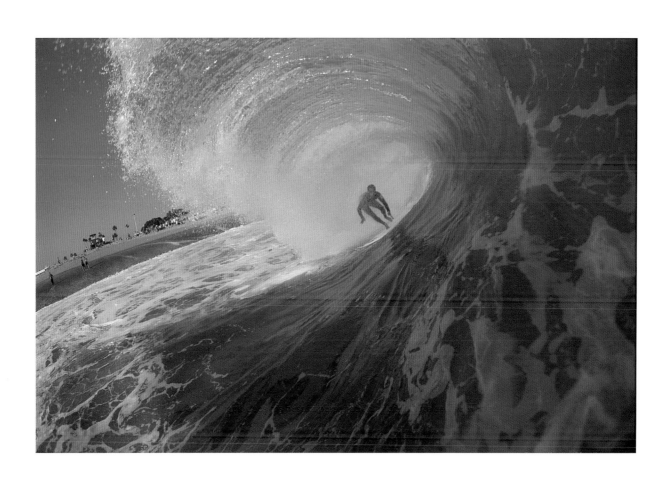

Danny Kwock does his best impersonation of childbirth at The Wedge.

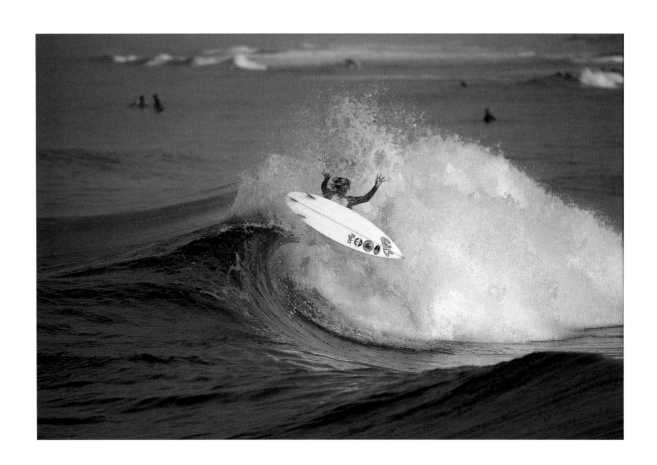

In the early eighties, single fins gave way to twins and thrusters. In the late eighties, off the lips evolved into full-fledged aerials.

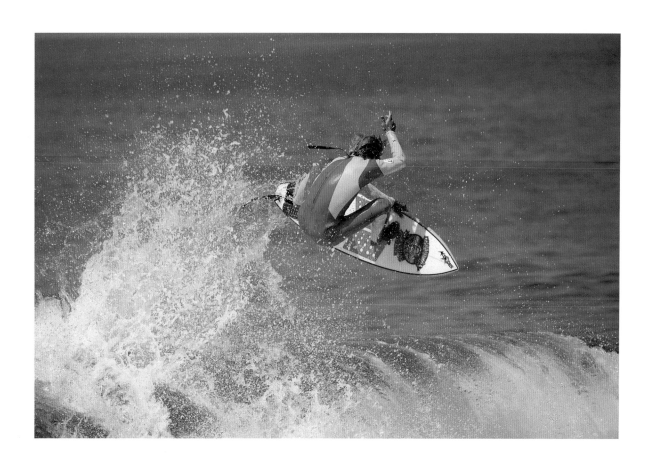

San Clemente's (L) Jim Hogan and (R) Christian Fletcher.

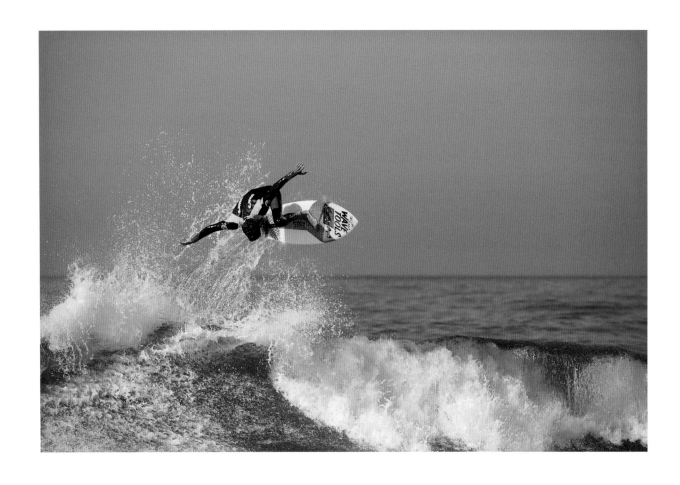

Richie Collins was one of the most outspoken pros of his generation. In interviews he openly discussed his Christian beliefs, masturbation, and the Mohawks he sported in the hope that they would ward off tempting women. Most memorable, though, are his big swooping moves in the surf.

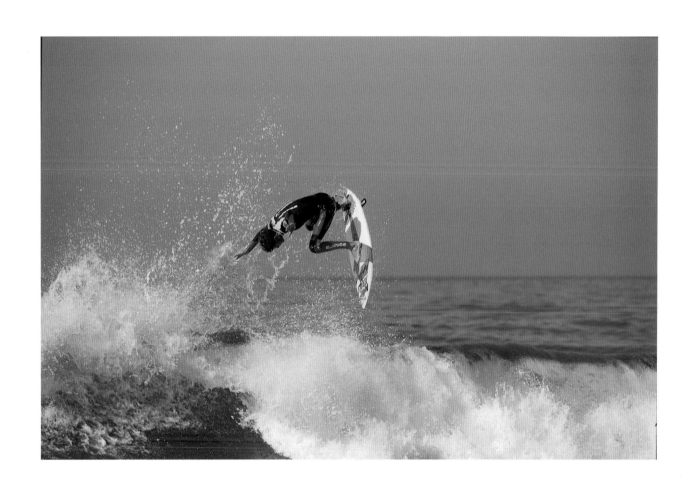

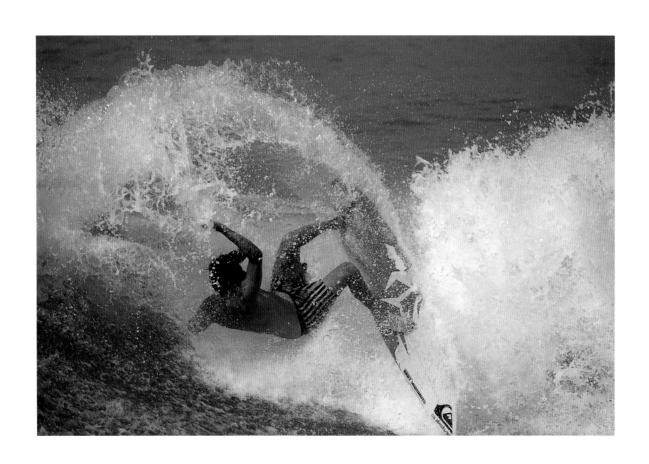

The late Dylan Crouch, dashing on water and endlessly entertaining on land.

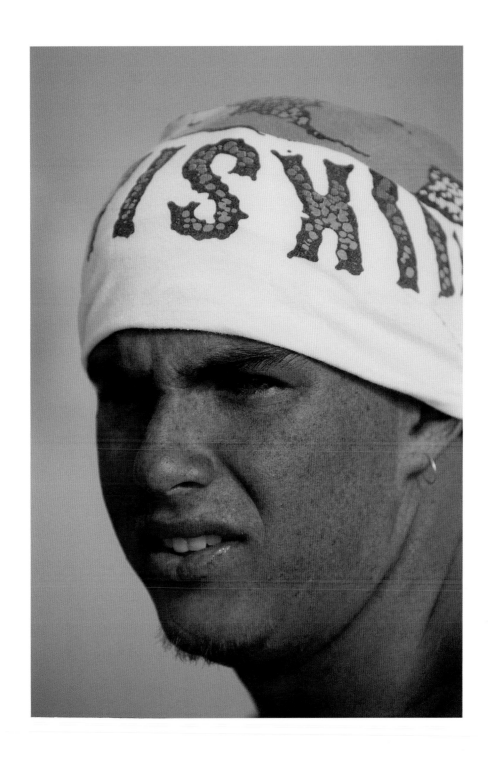

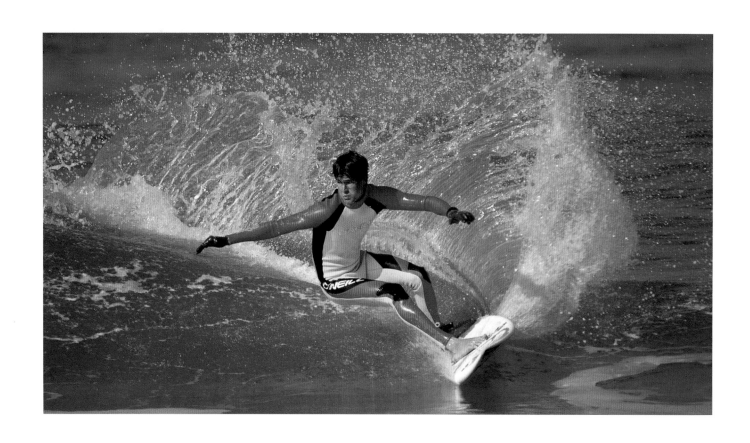

Parallel lines: (L) Mike Estrada and (R) Taylor Whisenand.

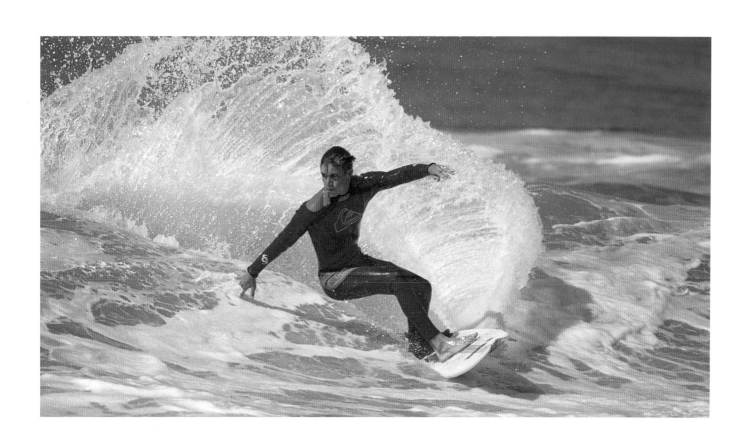

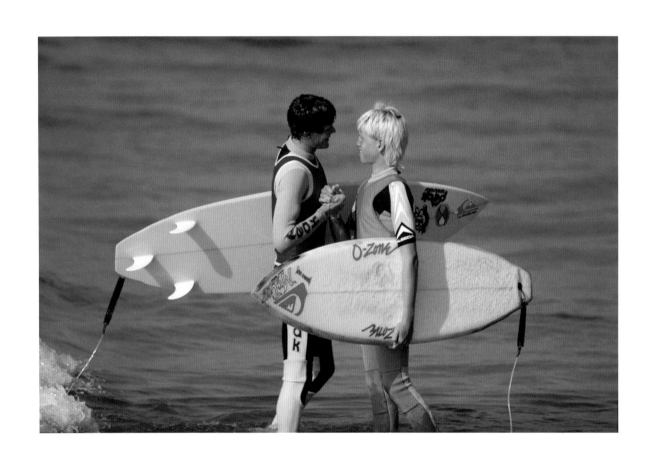

Mike Estrada and Todd Miller: friends first, bloodthirsty competitors second.

Three heavy hitters from the Quik youth squadron: Marc Belanger, Todd Miller, and Mike Estrada.

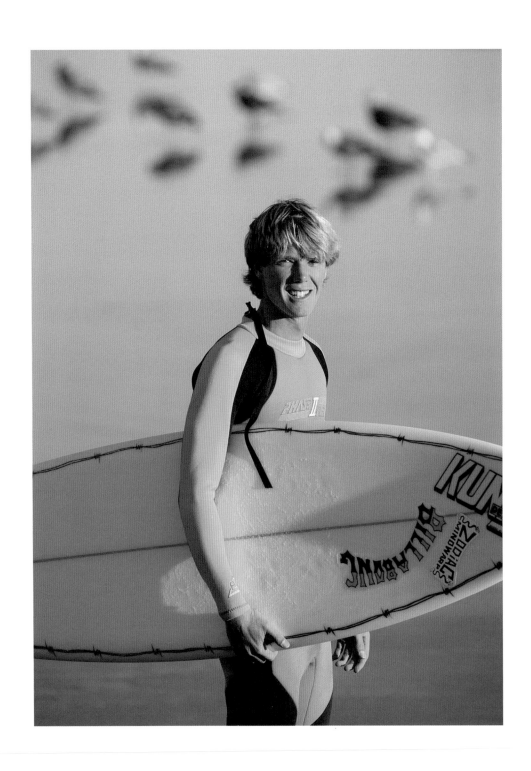

Smooth and stylish Dave Rose.

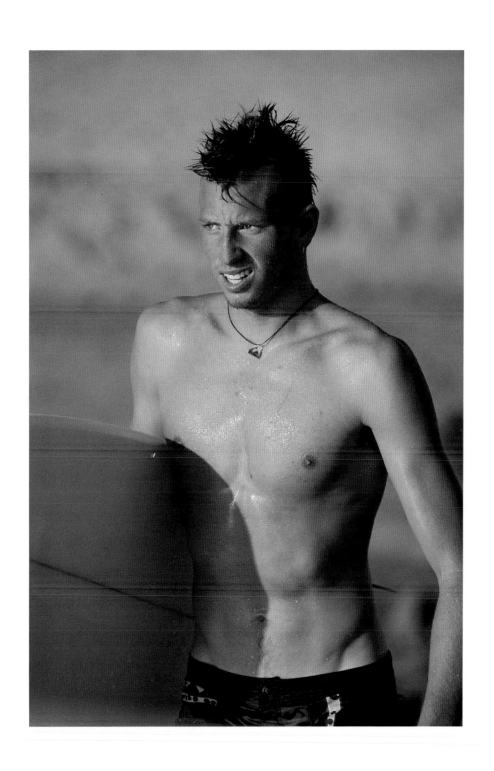

Nimble and electric Matt Patterson.

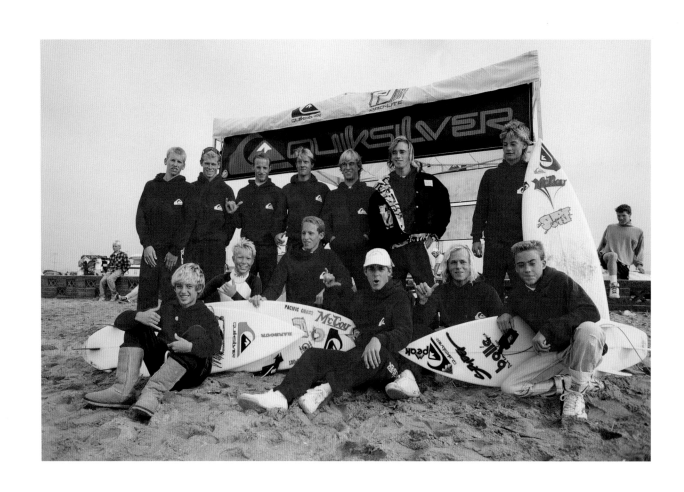

Quiksilver team riders, 1987.

A nascent version of "surf class," which would soon find its way into high school P.E. programs.

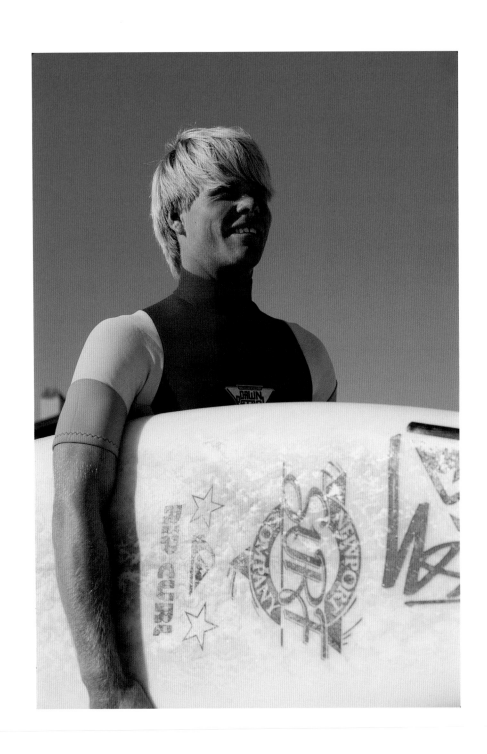

The mighty Mark "Smerk" Mangan.

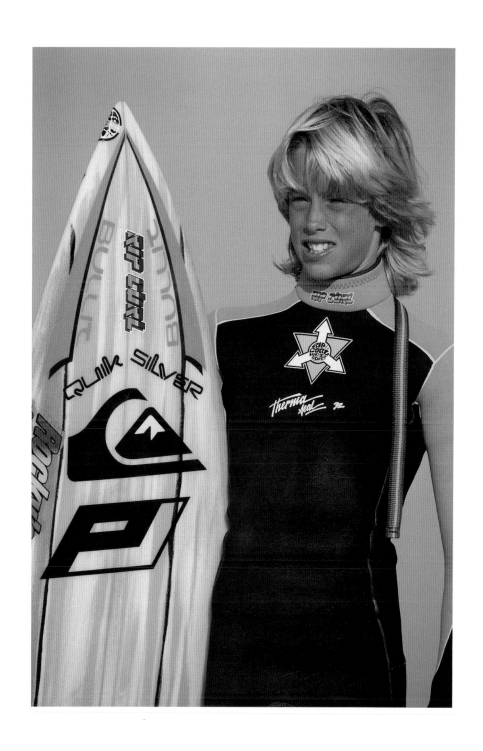

A young and hungry Micah Pitts.

A sea of blond: (L to R) Mark Goldsmith, Jamie Brisick, Cordell Miller, and R.S. Elliot.

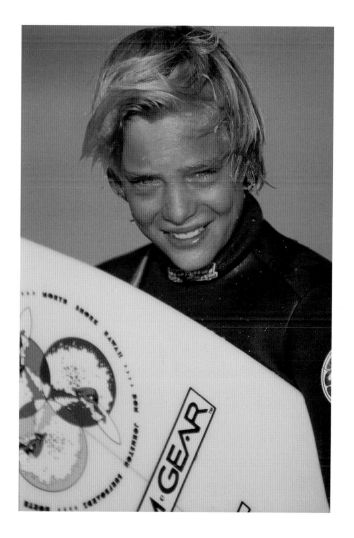

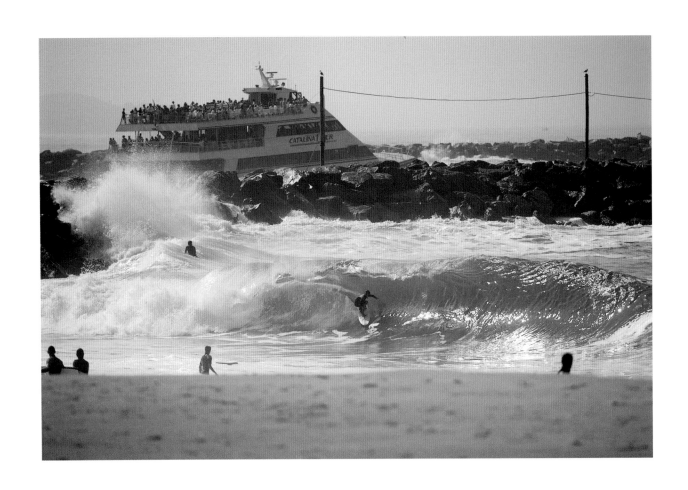

The gladiator pit that is The Wedge, with Danny Kwock pulling in to a medieval barrel. When it's on, it's one of the best shows on the California coast.

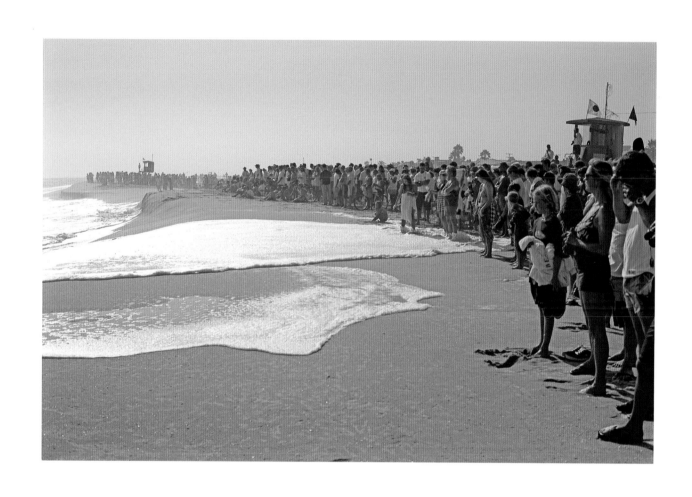

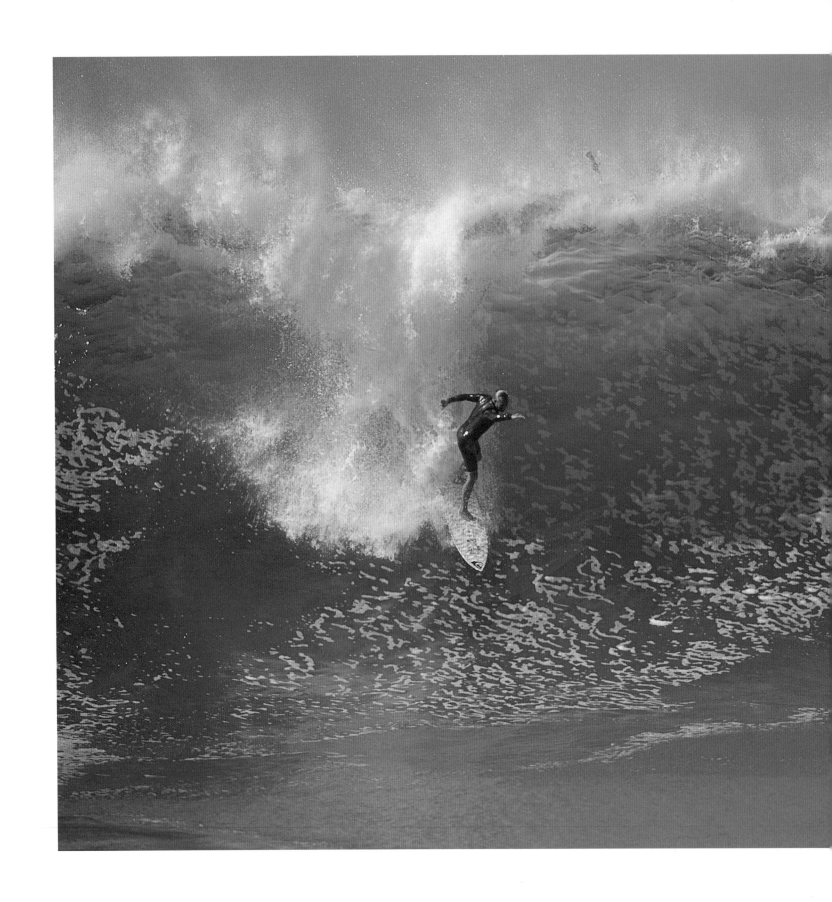

Santa Monica's Strider Wasilewski tackles The Wedge. Or maybe the other way around.

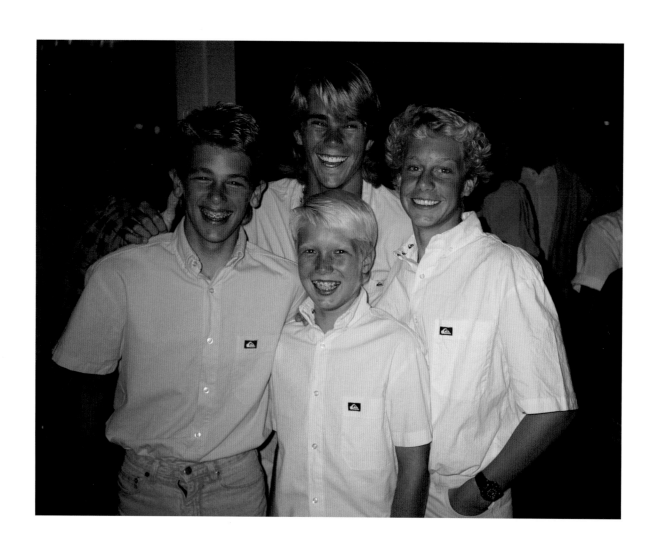

Quiksilver party, 1987: (clockwise from left) Rob Colby, Greg Ryan, Nicolai Glazer, and Ryan Simmons.

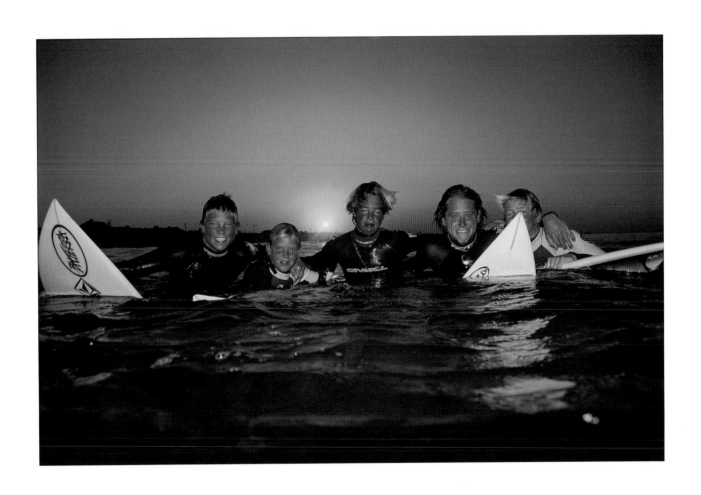

Team Volcom, circa early nineties: (L to R) Chad Towersey, Matt Murphy, Makai Makena, Troy Eckert, and Pat Towersey.

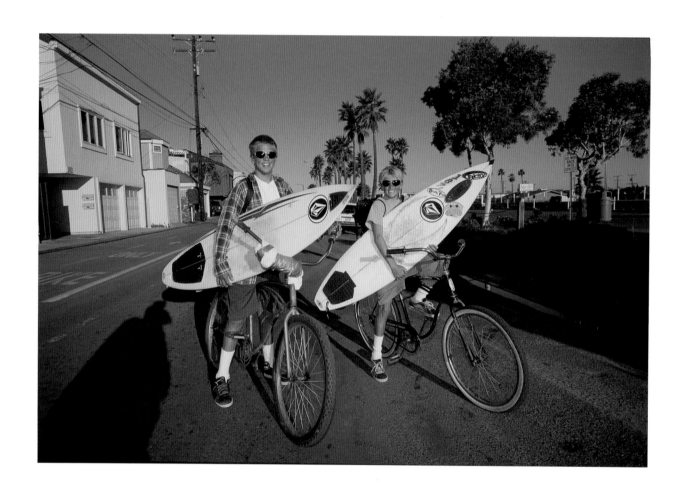

Brothers Chad and "Punker Pat" Towersey came of age in the early 2000s. Like many of their Echo Beach forefathers, they went from red-hot surfers to industry stalwarts. "I'm stoked to be able to tell the story," says Pat, a marketing director for RVCA. "It's great taking part in the larger culture."

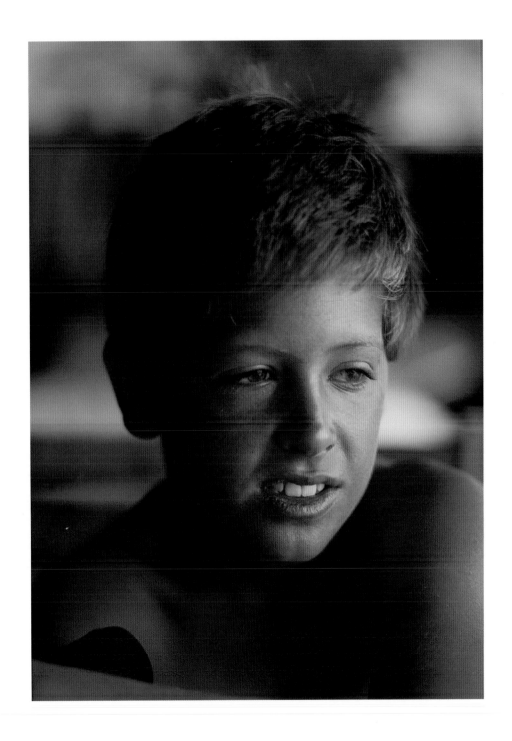

Andrew Doheny represents the newest generation of Echo Beach aces. He surfs, skates, blogs, plays guitar, and shapes his own board. "He's a great example of a guy using all the resources that are right here in our backyard," says "Punker Pat" Towersey. "And in the water he's incredible; right up there with all the best guys."

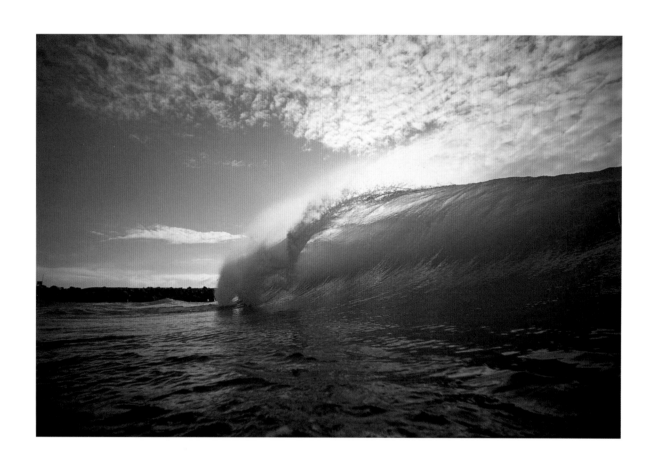

Echo Beach was a launchpad—for surfers, photographers, shapers, and clothing companies. But the real star was the wave.

PHOTOGRAPHS COPYRIGHT ©2011 MIKE MOIR (UNLESS OTHERWISE NOTED)

PHOTOGRAPHS COPYRIGHT ©2011 CHUCK SCHMID WHERE NOTED

TEXT COPYRIGHT ©2011 JAMIE BRISICK

FOREWORD COPYRIGHT ©2011 JOEL PATTERSON

DESIGN, EDITING, AND PRODUCTION TOM ADLER AND EVAN BACKES

THANKS TO BOB MCKNIGHT, MIKE HAYDIS, PARTNERS & SPADE, JEFF BOOTH,

STEFAN JEREMIAS, JEFF PARKER, AND KYLE HUFFORD

ALL RIGHTS RESERVED.

NO PART OF THIS BOOK MAY BE REPRODUCED IN ANY

FORM WITHOUT WRITTEN PERMISSION FROM THE PUBLISHER.

LIBRARY OF CONGRESS CATALOGING-IN-PUBLICATION DATA AVAILABLE.

ISBN: 978-1-4521-0489-8

MANUFACTURED IN CHINA

10 9 8 7 6 5 4 3 2 1

CHRONICLE BOOKS

680 SECOND STREET

SAN FRANCISCO, CA 94107

WWW.CHRONICLEBOOKS.COM

FOR MORE ON THE ERA, CHECK OUT THE AWARD-WINNING

DOCUMENTARY FILM ECHO BEACH WWW.ECHOBEACHFILM.COM